THE GREAT WESTERN RA

— VOLUME THREE —

PLYMOUTH TO PENZANCE

Stanley C. Jenkins & Martin Loader

AMBERLEY

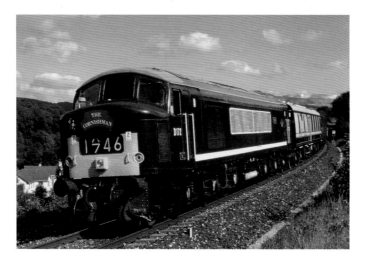

Near St Austell
Class '45' locomotive No. D172 *Ixion* rounds the curve at
Coombe, near St Austell, on 23 September 1995, with the 5.30 a.m.
Pathfinder Tours Coventry to Penzance 'Cornishman' rail tour.

ACKNOWLEDGEMENTS

Thanks are due to Mike Marr for the use of the photographs on pages 18, 24, 26, 30, 36, 48, 49, 66, 71 & 83. Other images were obtained from the Lens of Sutton Collection, and from the authors' own collections. Thanks are also due to Chris Turner for the loan of GWR timetables and other contemporary documents.

A Note on Distances & Closure Dates

The datum point for the calculation of distances on the West of England main line is Paddington station, the distance from Paddington to Penzance via Westbury and the Berks & Hants route being 305 miles 18 chains, while the distance via Bristol and the original main line is 325 miles 37 chains. As this publication is the third part of a trilogy dealing with the Paddington–Bristol–Penzance route, the distances quoted are via Bristol.

British Railways closure announcements referred to the first day upon which services would no longer run, which would normally have been a Monday. The final day of operation would usually have been the preceding Saturday or Sunday. The Fowey branch, for example, was closed *on* Saturday 2 January 1965, whereas the 'official' closure was said to have taken place *with effect from* Monday 4 January.

First published 2014

Amberley Publishing
The Hill, Stroud, Gloucestershire, GL5 4EP
www.amberley-books.com

Copyright © Stanley C. Jenkins & Martin Loader, 2014

The right of Stanley C. Jenkins & Martin Loader to be identified as the Authors of this work has been asserted in accordance with the Copyrights, Designs and Patents Act 1988.

ISBN 978 1 4456 3968 0 (print)
ISBN 978 1 4456 3980 2 (ebook)

British Library Cataloguing in Publication Data.
A catalogue record for this book is available from the British Library.

Typesetting by Amberley Publishing.
Printed in Great Britain.

INTRODUCTION

Cornwall is now regarded primarily as a holiday area, but it is also an important mining region. Rich deposits of tin, copper and (more recently) China Clay have traditionally formed the basis of Cornish mining activities, and these extractive industries have always required good transport facilities on land and by sea. Inevitably, Cornish landowners and entrepreneurs were active railway promoters, some of the earliest railways in the country having been built in Cornwall. In 1810, for example, the Poldice Tramway was opened from Portreath to mines near Scorrier, while in 1825 the Redruth & Chacewater Railway was opened between Redruth and Restronguet Creek, on the River Fal. The success of the Redruth & Chacewater Railway led to the promotion of other lines, one of these being the Cornwall Railway.

THE CORNWALL RAILWAY

The Cornwall Railway was formed in 1844, with the aim of constructing a rail link between Plymouth, Truro and Falmouth. This ambitious scheme received the Royal Assent on 3 August 1846, and the promoters were thereby empowered to construct a main line to Truro and Falmouth, with branches to Bodmin, Penryn and Newham quay. Further clauses allowed the Cornwall Railway to lease or purchase the Liskeard & Caradon Railway, and purchase the Bodmin & Wadebridge Railway and extend it to Padstow. To pay for their scheme, the Cornwall Railway promoters were authorised to raise no less than £1,600,000 in £20 shares – this was, needless to say, a phenomenal sum by early Victorian standards.

Although their company was an independent concern, the Cornwall Railway directors had formed an alliance with the Great Western Railway, which was permitted to subscribe £75,000 to the scheme. It was anticipated that this association would be advantageous to the smaller company, which was faced with severe engineering problems – particularly at Saltash, where the authorised route would be carried high above the River Tamar. As a corollary of this decision, it was agreed that the new railway would be built to the GWR broad gauge of 7 ft 0¼ inches. The Great Western link was underlined by the appointment of Isambard Kingdom Brunel (1806–59) as engineer to the scheme in place of Captain William Moorsom (1804–63), late of the 43rd Light Infantry, who had carried out the original surveys.

Unfortunately, a series of failed harvests and a severe economic crisis in the later 1840s blighted, not only the local potato crop, but also the Cornwall Railway, which languished unfinished in the sodden landscape while hungry labourers tramped the countryside in search of work. The picture of misery was completed by an outbreak of anti-railway riots staged by hungry labourers, who feared that, if completed, the new railway would enable outsiders to pour across the River Tamar and consume what little food was still available. In these circumstances, the Cornwall Railway scheme remained in abeyance for several years.

Eventually, a gradual improvement in the economy allowed work to resume on the section of line between Plymouth and Truro, and this major portion of the Cornwall Railway was ceremonially opened by Prince Albert on 2 May 1859. Regular

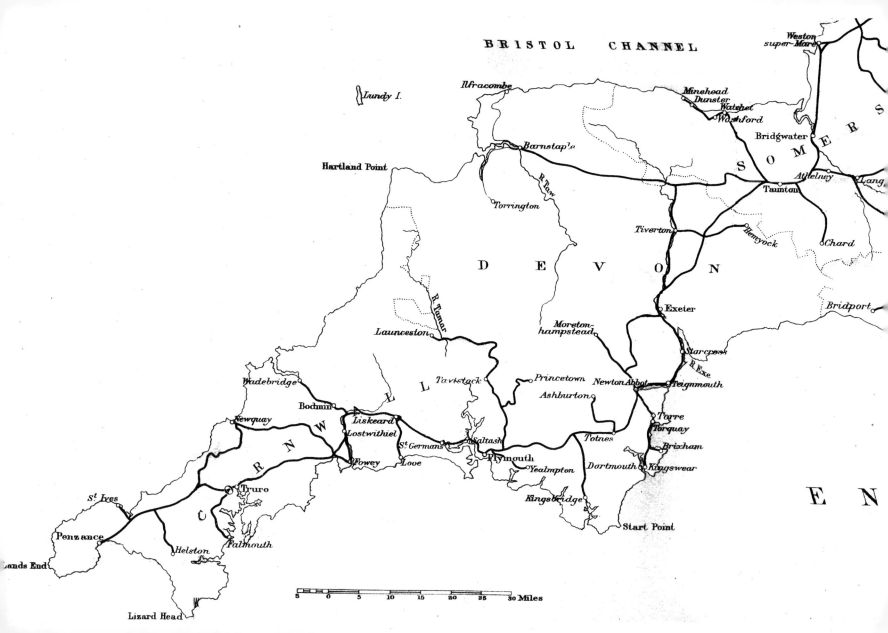

passenger services commenced on 4 May, the new line being managed by a joint committee of Great Western, South Devon, Bristol & Exeter and Cornwall Railway directors.

The new railway was a single-track, broad gauge route with crossing loops at the stations, and it was initially worked by Messrs Evans & Geach, who already worked the neighbouring South Devon Railway under contract. The Cornwall Railway route was heavily engineered, with five tunnels and no less than thirty-four major bridges or viaducts along its 53-mile route. Many of the viaducts were of the familiar Brunelian 'fan' type, with timber superstructures supported on lofty masonry piers. Others were of timber trestle construction, while the famous Royal Albert Bridge, at Saltash, was a mighty structure incorporating two 455-ft tubular iron spans and seventeen approach spans – its total length being 2,200 feet. The line was laid in the usual broad gauge manner, with bridge rails weighing 62 lbs per linear yard secured to longitudinal timber sleepers.

Meanwhile, there had been considerable disquiet concerning the lack of progress on the remaining part of the Cornwall railway route between Truro and Falmouth. In the days of sail, Falmouth had been an important Atlantic seaport and, at a time when the Cunard Line and other steamship companies were starting to monopolise the trans-Atlantic routes, it was regarded as essential that Falmouth should be linked to the national railway system, so that the Cornish port could effectively compete with Liverpool and Southampton.

The Falmouth traders and shipowners clearly felt that they had been forgotten, and Cornwall Railway meetings were often dominated by questions and arguments about the long delayed Falmouth extension. On 6 March 1858, for example, the *Railway Times* reported an exchange of views that had taken place at a recent Cornwall Railway meeting. Pointing out that no less than sixty-six vessels had entered Falmouth Harbour in January 1857 alone, an irate shareholder had pointed out that it was of 'vast importance to the country' that the port of Falmouth should be 'connected with the great places northward' with as little delay as possible. In reply to this statement, the chairman assured the assembled shareholders that their railway had been formed to build a rail link between Plymouth and Falmouth, and this aim was still of primary importance to the Cornwall Railway Co.

Extensions of time for completion of the Falmouth line had been obtained by the Cornwall Railway Acts of 12 July 1858 and 1 August 1861, and work was soon in progress on the remaining 12 miles, 61 chains of unfinished route between Truro and Falmouth. The line presented many engineering difficulties, tunnels being necessary at Sparnick (491 yards) and Perran (404 yards), in addition to the existing 70-yard bore at Penwithers. There would also be no less than eight huge timber viaducts, the longest, at College Wood, being over 900 feet long.

Work continued unabated for the next few months, and the Falmouth extension was virtually complete by the early months of 1863. Having passed its Board of Trade inspection, the railway was ceremonially opened on Friday 21 August 1863. Opening day was, as usual, celebrated in considerable style, with over 800 people being invited to take part in the proceedings. Falmouth was lavishly decorated with flags and bunting, while the ships assembled in the harbour were dressed with 'the flags of all nations'. The inaugural First Train was double headed by the locomotives *Wolf* and *Antelope*, and the celebrations continued long into the night. Regular services commenced on Monday 24 August 1863.

THE WEST CORNWALL RAILWAY

The newly opened Falmouth station was, for all intents and purposes, the terminus of the main line from Paddington, but in the event Penzance was destined to emerge as the primary destination for main line services between London and the far west – this development being attributable, at least in part, to the activities of the Hayle Railway and its successor, the West Cornwall Railway.

The Hayle Railway had been incorporated by Act of Parliament on 27 June 1834, and the first section of line, from Hayle to Carn Brea and thence to Portreath, was opened on 23 December 1837. The remaining section from Carn Brea to Redruth was completed on Thursday 31 May 1838. The Hayle line was constructed to the national gauge of 4 feet 8½ inches, and it was worked by a combination of locomotives and rope worked inclines. Passengers were carried on a regular basis from 22 May 1843 onwards, the first timetable providing three trains each way between Hayle and Redruth.

The Hayle Railway did not serve Penzance or Truro directly, but horse-drawn omnibuses were arranged between Hayle and Penzance, and from Redruth to Truro. By this means it was possible to travel through from Truro to Penzance, the fares from Truro being 3s 3d first-class passengers, 2s 3d for second class, and 2s for third-class travellers. The provision of this pioneering rail-road link may have encouraged the formation of a company known as the West Cornwall Railway, which in 1845 presented a bill to Parliament seeking consent for the construction of railways from Truro to Redruth, and from Hayle to Penzance, in connection with the existing Hayle Railway.

The 1845 proposals envisaged the West Cornwall line as an upgraded version of the Hayle Railway, and although the sections from Truro to Redruth, and from Hayle to Penzance would be entirely new lines, trains would continue to use the Hayle Railway between Redruth and Hayle. In the event, these proposals were rejected by Parliament on the grounds that the steeply graded Hayle Railway was totally unsuitable for use as a through route for main line passenger traffic.

Undeterred by the failure of their 1845 Bill, the West Cornwall promoters prepared a revised scheme for submission in the 1846 session. As in 1845, the proposals included new lines from Truro to Redruth and from Hayle to Penzance, but at the same time it was suggested that the Hayle line would be substantially rebuilt to eliminate the worst inclines en route. The 1846 West Cornwall Bill was, moreover, backed by the Great Western Railway and its allies, and with Isambard Kingdom Brunel as its engineer the scheme seemed destined for success. Parliament was of the same opinion and, on 3 August 1846, The West Cornwall Railway Bill received the Royal Assent.

The resulting Act of Parliament provided consent for the construction of a broad gauge railway commencing 'in the Parish of Kenwyn in the County of Cornwall', and terminating on 'the East Cliff at Penzance', with branches to Truro River and other specified places. To pay for their scheme, the West Cornwall Railway supporters were authorised to raise the sum of £500,000 in £20 shares, with borrowing powers for a further £165,000. The gauge of the 25-mile railway was to be 'that of the Great Western Railway', subject to the liability to lay additional rails of 'the gauge of any railway', which might later be constructed through Cornwall.

The West Cornwall Co. took possession of the Hayle Railway in November 1846, and for the next few years the WCR continued

to provide passenger and freight services over the existing line, using the Hayle Railway's original four locomotives. In 1850, the West Cornwall Co. obtained new powers, permitting deviations of the Hayle line, and allowing the company to construct the Truro and Penzance extensions as standard gauge lines. In this modified form, a line was opened from Trenowin to Penzance on 11 March 1852, while, on 25 August 1852, the eastern extension was completed from Redruth to a terminus at Higher Town, near Penwithers, on the western side of Truro.

There was, as yet, no physical connection between the standard gauge West Cornwall Railway and the neighbouring Cornwall Railway, which was of course a broad gauge route. However, on 15 August 1853, the West Cornwall Co. obtained parliamentary consent for two new lines in the Truro area. One of these, known as 'The Extension Railway', would run from the original WCR terminus at Penwithers to Gerras Wharf, on the Truro River at Newham. This line was opened on 16 April 1855, on which date West Cornwall services were extended from Penwithers to a riverside terminal at Newham.

The second line authorised by the 1853 WCR Act was described as 'The Junction Railway'. It commenced at Truro by a junction with the authorised line of the Cornwall Railway, and terminated 'by a junction with the ... Extension Railway in or near a field commonly called Ostler Field, numbered 254 on the Tithe Commutation Map of the said Parish of Kenwyn'. This line was opened on 1 August 1859, and it passed through Penwithers Tunnel in order to reach the Cornwall Railway station, which was equipped with mixed gauge trackwork in order to accommodate both WCR and Cornwall Railway locomotives, and rolling stock.

SUBSEQUENT DEVELOPMENTS

As mentioned above, the WCR had obtained permission to open its line as a standard gauge route on condition that, if called upon to do so, the WCR should add broad gauge rails to its system to provide a continuous 7-ft gauge route from London to Penzance. In 1864, the Cornwall Railway asked the WCR to lay broad gauge rails on its line between Truro and Penzance, but, having been asked to fulfill its broad gauge obligations, the WCR was unable to find the necessary funds. As a result, it was agreed that the West Cornwall line would be taken over jointly by the Great Western, Bristol & Exeter and South Devon railways from 1 January 1866, the WCR rolling stock being transferred to the 'Associated Companies' at valuation. The WCR line was, thereafter, managed by a Joint Committee composed of representatives from the Great Western, South Devon and Bristol & Exeter companies.

With the West Cornwall line in the hands of the Great Western and its allies, the mixed gauge was completed throughout from Truro to Penzance on 6 November 1866, when 7-ft gauge goods trains began running through to Penzance. Broad gauge passenger services commenced on 1 March 1867, from which date most of the traffic between Truro and Penzance was transferred to the broad gauge. From this date, Penzance, rather than Falmouth, became the terminus of the Paddington main line, while the Falmouth route was slowly, but inexorably, reduced to branch line status.

Meanwhile, the arrangements at Plymouth were far from satisfactory, in that through services to and from Cornwall had to reverse in the South Devon terminus at Millbay. To eradicate this problem, a direct east–west line known as the 'Cornwall Loop'

was constructed between North Road Junction on the South Devon line, and West Junction on the Cornwall Railway. This new connection was brought into use on 17 May 1876 and, a few months later, on 28 March 1877, a new station was opened on the 'Cornwall Loop' at Plymouth North Road – although the earlier station at Millbay remained in use until the Second World War.

The Bristol & Exeter and South Devon railways were absorbed by the GWR in 1876 and 1878 respectively, whereupon the West Cornwall Railway automatically became purely Great Western property. The Cornwall Railway remained in being as a nominally independent concern, though it had, for all practical purposes, been part of the GWR since 1876. This anomalous situation was finally resolved in June 1889, when the Cornwall Railway Co. was fully amalgamated with the GWR. From that time onwards, the West of England main line was wholly owned by the Great Western Railway.

The next stage in the evolution of the railway system in Cornwall came in the early 1890s, when the Great Western broad gauge was finally abolished. It was decided that the West of England main line and its broad gauge branches would be narrowed, in one huge operation commencing on Friday 20 May 1892. To facilitate this massive engineering feat, about 5,000 workmen were transported into the far west, while all broad gauge rolling stock was moved eastwards out of Devon and Cornwall in a series of special empty stock workings. The final broad gauge service from Falmouth, for example, departed at 8.15 p.m. and arrived in Truro at 8.45 p.m. From there, the 7-ft gauge stock was sent to Swindon.

Similar empty stock workings were run at intervals throughout the evening, the very last broad gauge train on the Cornish main line being the 9.45 p.m. from Penzance, consisting of two locomotives and empty stock from the last down Cornishman service. Once the broad gauge lines had been cleared of rolling stock, gangs of men began narrowing the track by moving one rail inwards on its longitudinal timber sleeper. The entire operation was accomplished with remarkable efficiency, and the first standard gauge test trains were run on Sunday 22 May, in order for the converted lines to be ready for the resumption of ordinary public traffic with effect from Monday 23 May 1892.

In physical terms, the abolition of the broad gauge did not entail many immediate changes. It is true that, in 1896, the GWR decided to rebuild Truro station, but this decision was prompted more by increasing traffic levels than any inherent problems with the original broad gauge infrastructure. The main alteration following the abolition of the broad gauge took place in connection with Penwithers Junction and the western approaches to Truro station. In February 1894, the independent lines through Penwithers Tunnel were replaced by a conventional section of double track, with a double-track junction for the Falmouth route and a new connection for the Newham goods branch.

THE DEVELOPMENT OF TRAIN SERVICES

The original timetable between Plymouth and Truro consisted of just five workings each way, and there were a similar number of services on the standard gauge West Cornwall line. Despite the break of gauge at Truro, the Cornwall and WCR companies made commendable efforts to arrange suitable connections for the benefit of through travellers to and from London.

At the time of its opening in 1859, the Cornwall Railway provided up workings from Truro to Plymouth at 6.20 a.m.,

8.00 a.m., 11.45 a.m., 3.35 p.m. and 6.29 p.m., while in the down direction the corresponding services departed from Plymouth at 6.05 a.m., 10.30 a.m., 2.15 p.m., 4.50 p.m. and 7.25 p.m. Most of these services were in fact through workings to Bristol and Paddington. The 8.00 a.m. 'express', for example, arrived in Exeter at 12.45 p.m. and reached Paddington by 6.00 p.m., giving an overall journey time of ten hours between Truro and London.

West Cornwall services departed from Truro for Penzance at 6.45 a.m., 9.10 a.m., 1.22 p.m., 5.20 p.m. and 7.15 p.m., with up workings from Penzance to Truro at 6.10 a.m., 9.55 a.m., 1.45 p.m., 4.58 p.m. and 7.14 p.m. The 7.14 p.m. ex-Penzance terminated at Newham, but otherwise there were good connections at Truro, and it was possible for people leaving Penzance on the early morning 6.45 a.m. up working to reach Paddington in about twelve hours, with an arrival time in London of 6.00 p.m. The 9.55 a.m. from Penzance connected with the 11.45 a.m. broad gauge service from Truro which reached London by 11.00 p.m., but travellers on the 1.45 p.m. mail train did not arrive at Paddington until 4.45 a.m.!

The level of service remained unchanged for several years, although there was a steady improvement in train speeds. Further incentive for improvement came in 1876, when the GWR effectively secured control of the broad gauge route from Paddington to Penzance. At that time, the most prestigious train service on the West of England main line was the 'Flying Dutchman', but in 1890 the 'Dutchman' was joined by a new service known as the 'Cornishman', which left Paddington at 10.15 a.m. and reached Penzance at 6.57 p.m. In the reverse direction, the balancing up service left Penzance at 11.15 a.m. and arrived in Paddington at 7.50 p.m.

In May 1890, *The West Briton* stated that there were, by that time, 'fifty passenger trains each day arriving and departing from Truro station, exclusive of luggage or excursion trains'. Eight of these workings were main line services to or from Plymouth, while nine trains ran to and from Penzance over the West Cornwall route. In addition, the Falmouth branch was served by eight trains each way, most of these being in connection with main line services between Plymouth and Penzance. In the early 1890s, trains left Truro for Falmouth at 6.50 a.m., 9.35 a.m., 11.32 a.m., 1.35 p.m., 3.10 p.m., 5.20 p.m., 7.40 p.m. and 8.10 p.m.

The narrowing of gauge was followed by a marked improvement, both in terms of frequency and timings. The 'Flying Dutchman', for example, was accelerated by 15 minutes, and it then became the fastest train in the world. The 'Cornishman' was also accelerated, although further progress did not really become possible until the completion of the 'Berks & Hants' Cut-Off in 1906. Thereafter, the West of England route went from strength to strength, and by 1922 there were six long-distance through services between Paddington and Penzance. The most important working was the celebrated 'Cornish Riviera Express', which had first been introduced as a seasonal service in 1904.

The 'Cornish Riviera' was transferred to the 'Berks & Hants' route in 1906, and it soon became the most famous express service on the GWR system. The 'Cornishman', meanwhile, was quietly dropped, its morning departure slot being filled by the 10.15 a.m. 'Cornish Riviera' departure from Paddington. In 1935, the 'Cornishman' was briefly revived as a relief service for the ever-popular 'Cornish Riviera', but, otherwise, the 'Cornishman' was absent from the timetables until 1952,

when its name was applied to a long-established express service between Wolverhampton and Penzance. This service, which then ran on weekdays only, has survived until recent years as a long-distance working from Edinburgh to Penzance.

Mention of the 'Cornishman' serves as a reminder that, in addition to its primary role as a vital link between London and Cornwall, the West of England main line also carried long-distance cross country traffic between the West Country and places as far away as Scotland. In the 1930s, for instance, there were around half a dozen trains between Penzance, Truro and London, with departures from Penzance at 9.00 a.m., 10.00 a.m. (the 'Cornish Riviera'), 10.15 a.m., 10.45 a.m., 11.10 a.m., 1.30 p.m. and 9.30 p.m. Of these trains, the 10.15 a.m. ex-Penzance travelled via Bristol, where it was divided, with one portion going to Paddington while the restaurant car portion continued northwards to Liverpool and beyond.

The 10.45 a.m. up service was also routed via Bristol, and it then continued northwards to Birmingham Snow Hill and Wolverhampton Low Level. This train (which became the named 'Cornishman' service in BR days) conveyed a through portion for Aberdeen. The long-distance through portions were composed of non-Great Western rolling stock, the 10.15 a.m. from Penzance being formed partly of maroon LMS vehicles, while the Aberdeen through coach was a varnished teak LNER vehicle that appeared strangely alien amid the familiar chocolate and cream Great Western rolling stock. The long-distance through workings were of course balanced by corresponding services in the down direction.

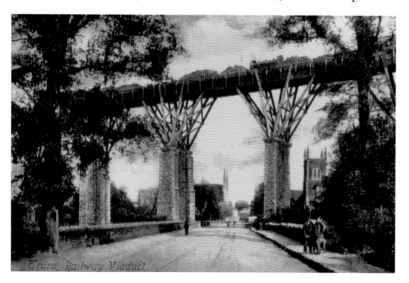

Cavedras Viaduct
The original Cavedras 'fan viaduct', as depicted on an Edwardian colour-tinted postcard of around 1902. There were thirty-four timber viaducts on the Cornwall Railway main line between Plymouth and Truro. Stonehouse Pool Viaduct, in Plymouth, was built for double track, but the others were built to carry a single broad gauge line.

Plymouth Millbay

When opened in 1859, the Cornwall Railway had shared the South Devon Railway station at Plymouth Millbay. This station had originated in 1849 as a simple terminus, with three platform lines beneath a wooden train shed and an additional platform for fish traffic. The station was extensively rebuilt at the end of the nineteenth century in order to provide a more modern terminus, with substantial stone buildings in place of the earlier facilities. There were, however, still three main terminal platforms, with a shorter bay on the east side – a proposed extra platform on the western side was never constructed. In its rebuilt form the station lost its overall roof, but the four platforms were covered by extensive canopies. The platforms were numbered from 1 to 4, platform 1 being the short bay, while platforms 2, 3 and 4 were the main terminal roads.

In October 1895, the GWR Traffic Committee proposed that £4,500 should be spent on a signalling scheme for the remodelled Millbay station, and a 117-lever signal box was eventually erected. The new cabin was inspected by the Board of Trade inspector on 10 July 1899, at which time it contained ninety-nine working levers. As a result of a subsequent resignalling carried out in 1914, Millbay acquired a new 115-lever box.

Millbay remained in use until April 1941, when it sustained severe bomb damage during the Plymouth Blitz. The adjacent goods depot was destroyed, and it was therefore decided that the passenger station would be closed, so that the platforms could be utilised for goods traffic. The station was never reopened, although empty stock workings continued to run to and from the earlier terminus, and in post-war years boat trains worked through Millbay on their way to Plymouth Docks, using a connecting line that skirted the western side of the station. The photographs show the station approach during the early years of the twentieth century.

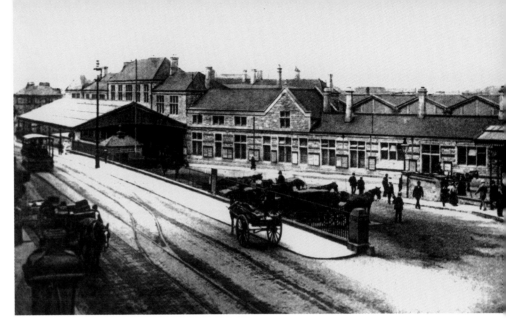

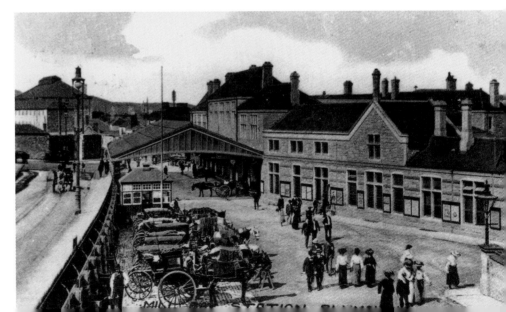

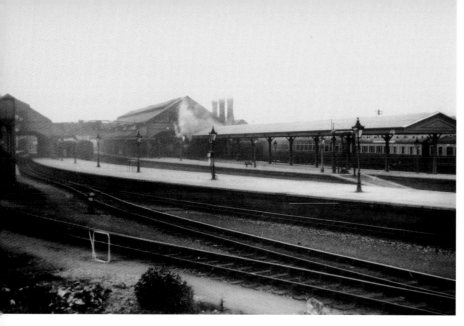

Plymouth North Road – The Old Station

Although adequate in relation to local traffic, Plymouth Millbay was designed as a terminus and, as such, it was unsuitable for use by through passenger workings. As mentioned earlier, a new station was therefore constructed on a fresh site at Plymouth North Road, to the north of the original terminus. This new facility was brought into use on 28 March 1877.

Built to plans drawn up by Peter J. Margary (1820–96), the GWR divisional engineer, Plymouth North Road station was constructed mainly of timber, its platforms being covered by an overall roof with a total span of 150 feet. The roof covering consisted of two gable roof sections, each of which had a width of around 46 feet. The centre part of the station was left uncovered to facilitate smoke emission, though the three centre tracks were spanned by transverse girders that linked the twin train sheds. By the end of the Victorian period, North Road consisted of four through platforms beneath the overall roof, with additional dead-end bays on each side. Unusually, the northern and southernmost through lines were flanked by two platform faces, which gave travellers the option of alighting from either side of their trains. The main station buildings were situated on the down (westbound) side.

In 1922, a GWR staff census reveals that over seventy people were employed at North Road during the early 1920s, rising to 115 by 1939. The staff census provides a glimpse of the labour force needed to run this busy station which, at that time, comprised one 'Special Grade' stationmaster, 6 booking clerks, 3 station inspectors, 3 station foremen, 5 ticket collectors, 5 train ticket collectors, 19 porters, 3 parcel porters, 1 travelling parcels porter, 1 excess luggage collector, 1 cloakroom attendant, 1 waiting room attendant, 3 passenger shunters, 6 signalmen, 2 telegraphists, 11 guards and 1 charwoman.

The upper photograph is a general view of the old station, looking east towards Paddington around 1922. The lower view shows experimental 4-4-2 locomotive No. 40 *North Star* at Plymouth North Road, probably around 1907.

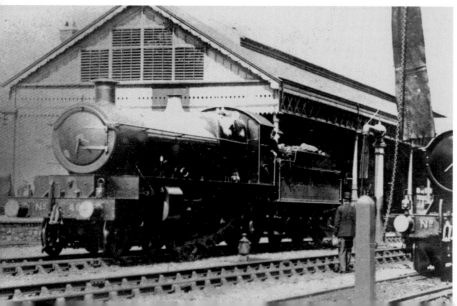

Plymouth North Road – Southern Locomotives

The London & South Western Railway reached North Road on
17 May 1876, L&SWR trains being able to enter Plymouth by
means of running powers over the Launceston branch. The opening
of the Plymouth, Devonport & South Western Junction line on
2 June 1890 furnished the L&SWR with an independent route from
Lydford, but South Western trains continued to use North Road
station en route to their own terminus at Plymouth Friary.

North Road was built as a 'joint' station to accommodate GWR
and L&SWR traffic, although joint ownership was, in practice,
limited to the station itself – the approach lines on either side being
exclusively Great Western property. The London & South Western
Co. was, moreover, treated as the junior partner, 83 per cent of the
gross receipts for local traffic being allocated to the Great Western
as owner of the line, while the booking system in force at the station
ensured that the Great Western would retain a virtual monopoly of
traffic for stations west of Okehampton. London & South Western
(later Southern Railway) staff were left in no doubt that, for all
intents and purposes, Plymouth North Road was a Great Western
station. For example, the 1922 *London & South Western Working
Appendix* stipulated that, when vehicles were detached from L&SWR
trains at North Road, the necessary work would be carried out
entirely by GWR employees – this order being given 'so as to prevent
the possibility of vehicles being detached and left upon the Running
Lines without the knowledge of the Great Western Staff'.

The upper picture shows ex-L&SWR 'S11' class 4-4-0 No. 399
at North Road, with a Southern train from Plymouth Friary; these
engines were built in 1903 for passenger work in the West Country.
The lower view shows former L&SWR 'O2' class 0-4-4T No. 232
with a local passenger working.

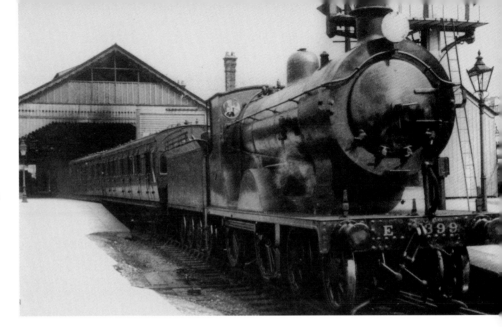

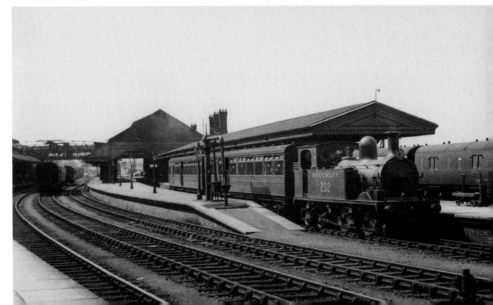

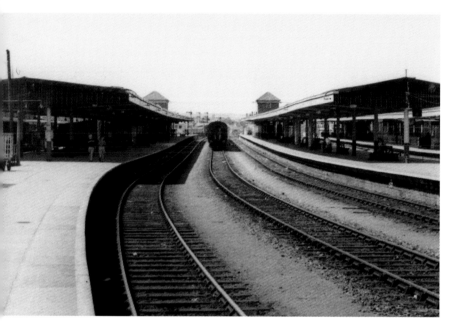

Right: **Plymouth North Road – The Rebuilt Station**

In 1956, British Railways resumed reconstruction work as part of a £1 million modernisation scheme, and the new station was officially opened by Dr Richard Beeching, the chairman of the British Transport Commission, on 26 March 1962. The rebuilt Plymouth North Road station consisted of seven through platforms, with additional dead-end bays for parcels and local traffic. The down side buildings were entirely rebuilt in an uncompromisingly modern style, incorporating extensive glass and concrete platform coverings and a ten-storey office block that housed the staffs of the district superintendent, the district engineer and various other departments. The new tower block was accompanied by a spacious concourse, which was linked to the platforms by an underline subway. The new facilities included a booking hall, enquiry offices, waiting rooms, and the appropriately named 'Brunel Bar' and dining room.

Left: **Plymouth North Road – The Old Station Building**

The GWR started to rebuild the station during the 1930s, the idea being that the existing four platform layout would be remodelled, with seven through platforms and extensive new buildings. Much of the proposed work was completed, although further progress was halted by the outbreak of the Second World War on 3 September 1939. Plymouth was severely damaged during the ensuing conflict, and some local people claimed that the city was 'the worst blitzed' in the country (the inhabitants of Coventry and Belfast might have disagreed). North Road station was damaged by enemy action on the night of 20/21 March 1941, when a high-explosive bomb landed on the subway and brought down part of the newly erected platform covering. The photograph, probably taken around 1950, shows the station in a partially rebuilt state.

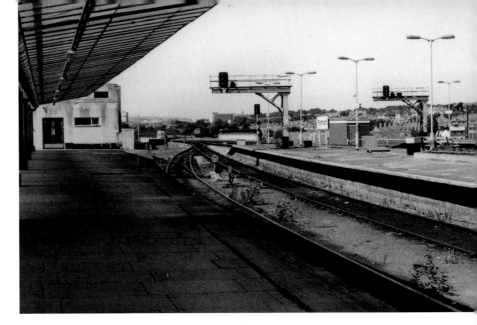

Plymouth North Road – Platform Alterations

In 1974, British Railways introduced further changes, as a result of which platforms 2 and 3, on the down side of the station, were converted into four terminal bays, leaving platforms 4, 5, 6, 7 and 8 in situ as through platforms catering for main line traffic. To facilitate this modification, a section of track in front of the main concourse was filled in and travellers were then able to walk from the concourse onto platform 4 without passing through the subway. A truncated platform 3, at the west end of the station, became a terminal bay for Callington branch trains, but the other bays were not numbered, as they were used mainly for parcels and mail traffic.

In its present-day form, North Road station exhibits a curious mixture of architectural styles. The non-numbered platforms in front of the ugly 1960s station buildings are covered by substantial canopies, but the other platforms are graced by lightweight canopies supported by H-girder uprights. The platform buildings include several hip-roofed, tile-hung structures, which presumably date from the earlier stages of the reconstruction scheme. Examination of the buildings on the northernmost island (platforms 7 and 8) reveals some Art Deco-type pilaster mouldings, which hint at the style of architecture that the GWR would have adopted if the Second World War had not intervened.

The upper picture shows the western end of the platforms, looking west towards Penzance, while the lower view shows an HST set in platform 8 in March 1996.

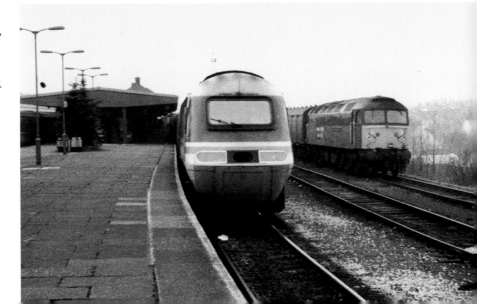

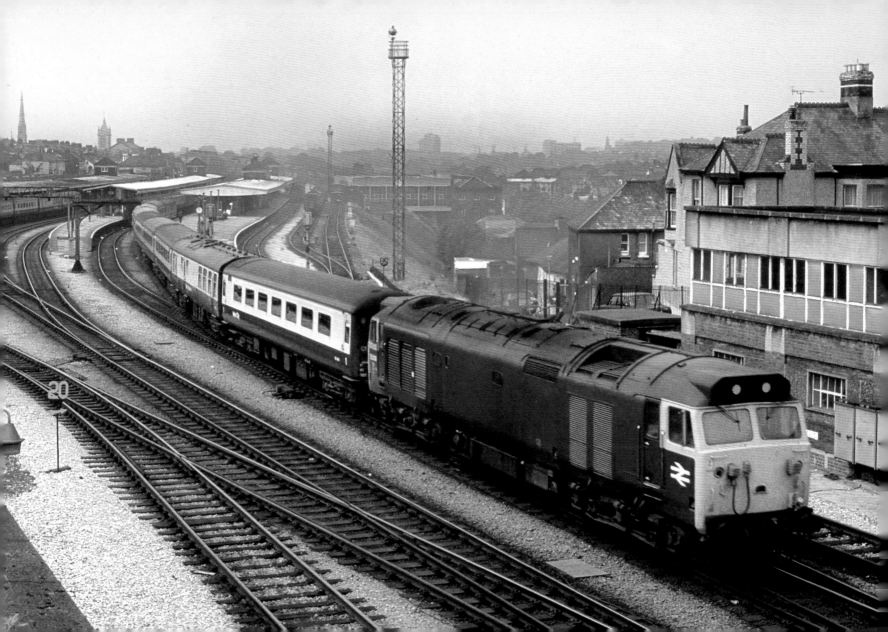

Plymouth North Road

Above: Class '08' shunting locomotive No. 08937 carries out its duties at Plymouth North Road on 4 July 1979. The two dead-end sidings to the right of the platforms 7 and 8 are known as the'Park Sidings', and they are used for stabling purposes. No. 08937 still resides in the West Country, having been preserved at the fledgling Dartmoor Railway, which has been set up on part of the former L&SWR line from Crediton to Meldon Quarry.

Below: A selection of tickets issued at Plymouth North Road, Plymouth Millbay and Keyham stations, including two British Railways rail tour tickets and a North Road platform ticket. Plymouth North Road issued 204,330 tickets in 1903, the corresponding figures for 1913 and 1923 being 246,245 and 352,153 respectively. There was, thereafter, an apparent decline in the number of ordinary bookings, around 250,000 tickets being issued per annum during the mid to late 1930s. On the other hand, the fact that some 5,000 season tickets were sold each year during the late 1930s would indicate that many regular travellers preferred to pay for their journeys in this convenient way. In 1938, the station issued 252,461 ordinary tickets and 5,011 seasons, while parcels traffic amounted to around 600,000 parcels and miscellaneous packages per annum during the period from 1936 to 1939.

Opposite: Plymouth North Road

A panoramic view of Plymouth North Road station, looking west towards Penzance on 17 April 1979. Class '50' locomotive No. 50021 *Rodney* is leaving platform 7 with an eastbound InterCity working. Plymouth North Road East signal box, to the right of the locomotive, was closed in November 1960, but the redundant building was retained for use by the permanent way department.

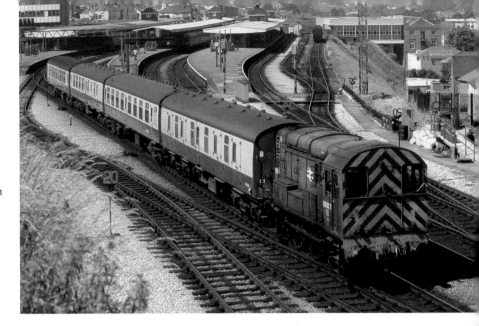

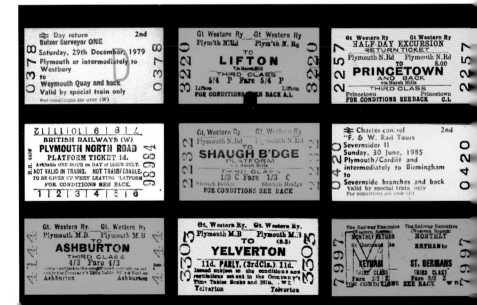

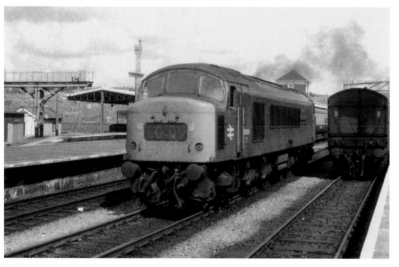

Plymouth North Road

Left: Class '45' locomotive No. 45049 *The Staffordshire Regiment* at Plymouth North Road around 1978.

Below left: Class '50' locomotive No. 50014 stands alongside platform 5, with a cross-country service to Leeds during the late 1970s; No. 50014 was subsequently named *Warspite*. Introduced in 1967, these locomotives were built by English Electric, and they were initially employed on the West Coast Main Line between Crewe and Glasgow. They were subsequently transferred to the Western Region, after which they were fitted with warship names that reflected the maritime traditions of the West of England.

Below right: Class '50' locomotive No. 50021 *Rodney* at Plymouth North Road on 17 April 1979. No. 50021 had been named at the nearby Laira depot the previous year, and followed in the footsteps of LMS 'Jubilee' class 4-6-0 No. 45643 in being named after a Royal Navy battleship.

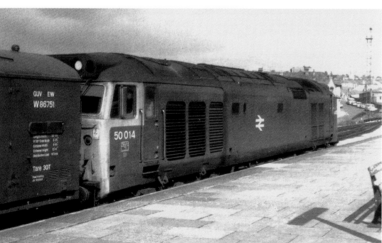

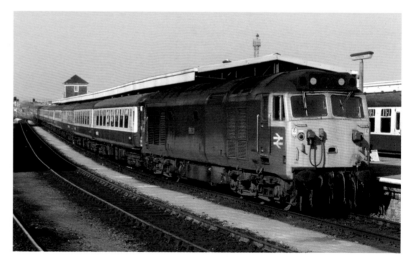

Devonport Albert Road

On departing from Plymouth North Road, trains cross Saltash Road on a girder bridge, after which the original line to Plymouth Millbay formerly diverged to the left. Travelling on the 1876 'Cornwall Loop', present-day trains head westwards passing, on the left, the remains of Stonehouse Pool Viaduct on the disused Millbay route; the viaduct, originally of timber, was reconstructed with iron girders in 1908. The abandoned south-to-west curve from Millbay converges with the main line at West Junction, beyond which, a further junction known as Devonport Junction formed a connection between the GWR and the nearby London & South Western line. Devonport Junction was controlled from a signal cabin on the up side of the line. This box, which replaced an earlier cabin around 1900, contained a 31-lever frame; it was closed in November 1960 in connection with the Plymouth resignalling scheme.

Heading westwards, down trains pass the site of Wingfield Villas Halt, which was opened on 1 June 1904 and closed in June 1921. The still extant suburban station at Devonport (247 miles 15 chains), is only a short distance further on. Opened by the Cornwall Railway on 4 May 1859, Devonport was a fully-equipped station with a range of facilities for passengers, parcels, coal, livestock and general merchandise traffic. The goods yard was situated at the west end of the station, and the signal box, with a 29-lever frame, was on the down side. The signal cabin was closed in November 1960, but the station remains open for passenger traffic, albeit as an unstaffed halt. The upper picture shows class '50' locomotive No. 50040 at Devonport Junction on 4 March 1978, while the lower view provides a glimpse of Devonport station during the early 1960s; No. 50040 was subsequently named *Leviathan*.

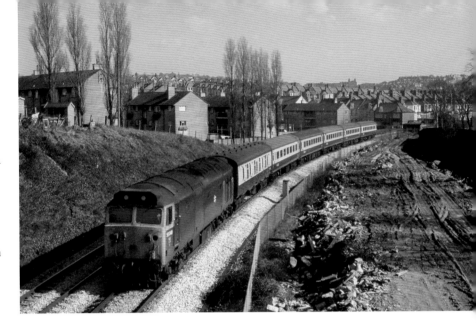

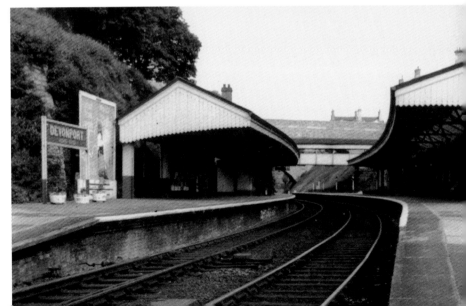

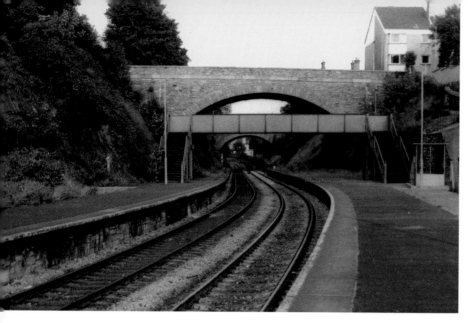

Devonport Albert Road

Above: A later view of Devonport, looking east towards Paddington during the 1980s, by which time the station had been reduced to the status of an unstaffed request stop.

Below: A view west towards Devonport tunnel. By the end of the Victorian period, this part of the Plymouth conurbation had evolved into an important industrial area, and local stations such as Devonport and Keyham were used by large numbers of dockyard workers. The original dockyard was established at Point Forward, about a mile to the south-west of Devonport station. This first dockyard subsequently formed the nucleus of the 'South Yard', while an entirely new 'Steam Yard' was opened at Keyham in 1853. Keyham Steam Yard, sometimes referred to as the 'North Yard', was greatly extended at the end of the nineteenth century when Sir John Jackson, the engineer of the Manchester Ship Canal, was engaged by the Admiralty to carry out an ambitious extension scheme under the provisions of the Naval Works Act 1895.

The new facilities were completed in February 1907, by which time the dockyard extended from Mutton Cove in the south to Weston Mill in the north, a distance of around 2 miles. The dockyard was capable of a wide range of work, including the construction of major warships such as the 'Dreadnought' battleships – HMS *Marlborough* (1912), HMS *Warspite* (1913) and HMS *Royal Oak* (1914). Vessels completed between the wars included cruisers such as HMS *Devonshire* (1927) and HMS *Birmingham* (1936), while, after the Second World War, the dockyard constructed anti-submarine frigates such as HMS *Cleopatra* (1966) HMS *Danae* (1967) and HMS *Scylla* (1970).

The dockyard contained an extensive internal railway system, and this was linked to the Cornwall Railway in August 1867, when a broad gauge connection was installed between the main line and Keyham Steam Yard. When the L&SWR was opened to Devonport, the Admiralty insisted that the dockyard branch should be 'mixed' to allow the passage of standard gauge traffic. The GWR therefore laid a third rail over the main line as far as Keyham station, while the Cornwall Railway agreed to install the additional rails within the yard itself.

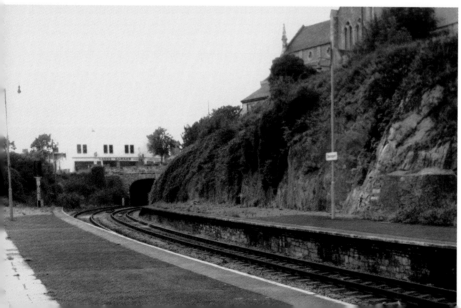

Dockyard Halt

Above: On leaving Devonport, the line enters Devonport Tunnel and turns onto a northerly alignment. Trains soon reach the next stopping place at Dockyard Halt (247 miles 47 chains), which was opened on 1 June 1905 and is still in use. The photograph is looking west towards Penzance, probably during the 1920s.

Below right: A c. 1960 view, looking east towards Paddington. Some of the buildings seen in the earlier photograph appear to have been demolished, possibly as a result of wartime bomb damage.

Below left: Class '50' locomotive No. 50044 *Exeter* passes through Dockyard Halt with a ballast train, presumably from Meldon Quarry, on 22 March 1979.

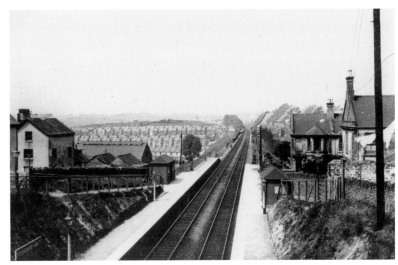

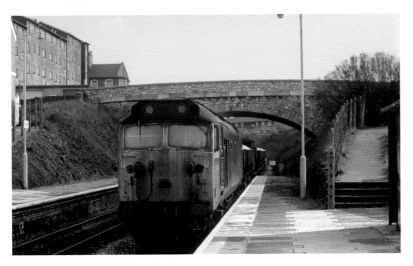

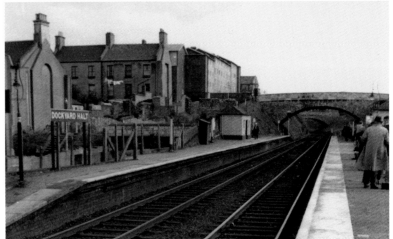

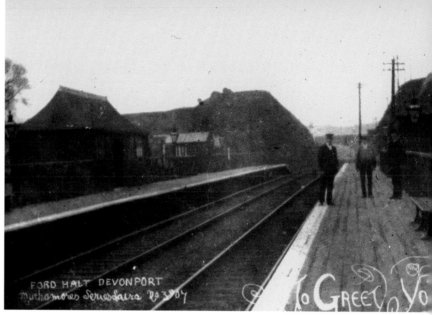

FORD HALT DEVONPORT

Ford Halt – Wartime Damage

From Dockyard Halt, the route runs northwards through a continuously built-up urban area, with tantalising views of Devonport Dockyard to the left of the railway. Ford Halt (247 miles, 66 chains) was opened on 1 June 1904 and closed following bomb damage sustained on the nights of 21/22 April and 29/30 April 1941. The photographs show the wooden platforms, which suffered severely during the wartime raids, despite the valiant efforts of Grade 1 Porter Frederick J. Harris, who continued to fight the fires until the water supply failed.

Keyham – The Dockyard Railway

Keyham (248 miles, 11 chains) was opened on 2 July 1900. Up and down platforms were provided here, the main station buildings of standard GWR design being on the down platform, while the goods yard, with its large brick-built goods shed, was on the opposite side of the running lines. The black-and-white picture is looking west towards Penzance during the early 1900s, while the colour photograph shows class '50' locomotive No. 50033 *Glorious* alongside the down platform, with the 4.35 p.m. Plymouth to Penzance service on 31 May 1978.

In operational terms, Keyham was significant in that it was the junction for the Dockyard branch, which joined the main line by means of a trailing connection at the west end of the station. The dockyard system extended southwards from Keyham to the North Yard, and thence through a 946-yard tunnel to the South Yard. Passengers were carried in archaic, short wheelbase vehicles, no less than six 'classes' being catered for, ranging from admirals to dockyard labourers. Passenger services were officially withdrawn on Monday 16 May 1966, but internal goods traffic was handled until 10 November 1982. On that day, the last train passed through the tunnel from the South to the North yards, the event being commemorated in suitable fashion by a small ceremony.

A siding connection nevertheless remained in situ between Keyham and the North Yard, so that supplies and equipment could be transported to and from the dockyard as required. In recent years, the main form of traffic has been waste material from nuclear submarines, which is taken by rail for reprocessing at Sellafield. However, in the 1990s, the dockyard carried out a range of maintenance work for BR and, in connection with these contracts, HST sets and other vehicles were shunted into the North Yard via the dockyard siding.

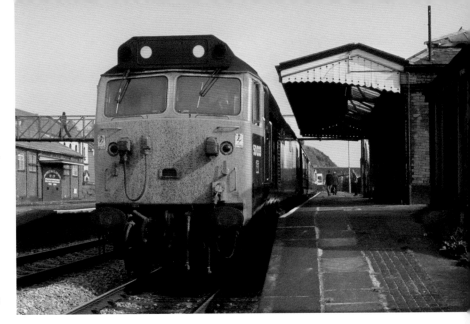

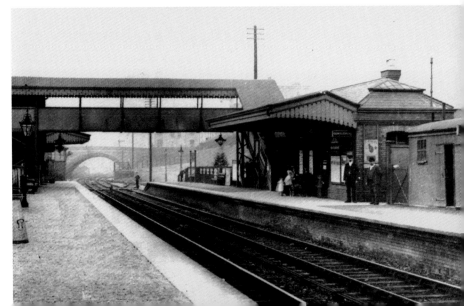

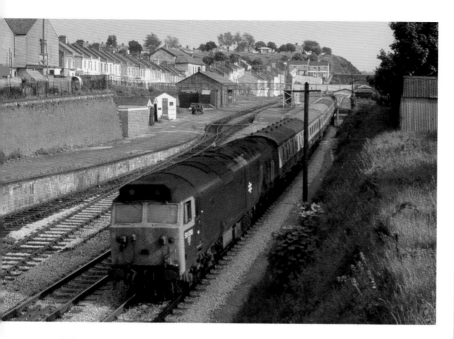

Right: Keyham – Porter F. J. Harris BEM

A detailed view of the down side station building. Keyham station and the surrounding area was heavily-bombed during the Second World War, the raids that took place on the nights of 21, 22 and 23 April 1941 being particularly severe. Large numbers of incendiary bombs landed on the station and in the goods yard, but Porter Frederick Harris, who has already been mentioned in connection with the bombing of Ford Halt, took charge of the firefighting operations and managed to extinguish many of the fire bombs that had fallen around wagons packed with high explosives. On 6 December 1941, *The Times* reported that Frederick John Harris had been awarded the British Empire Medal in recognition of his bravery during the Plymouth Blitz – his example and leadership having been an inspiration to those around him.

Left: Keyham

Class '50' locomotive No. 50050 *Fearless* passes through Keyham station with a down train on 31 May 1978. In 1910, the siding at the rear of the up platform was altered to form a new 'Up Back Platform Loop'. The Back Platform Line was further extended in 1936 and this, in turn, involved the provision of a new frame in the standard GWR signal box – the number of levers being increased from 33 to 59. The signal box was damaged in an air raid on the night of 29/30 April 1941, when a high-explosive bomb blew a huge crater in the up line and derailed 'Hall' class 4-6-0 No. 4911 *Bowden Hall*, damaging the locomotive beyond repair. The train crew survived, having left the locomotive and taken shelter under the steps of the signal box.

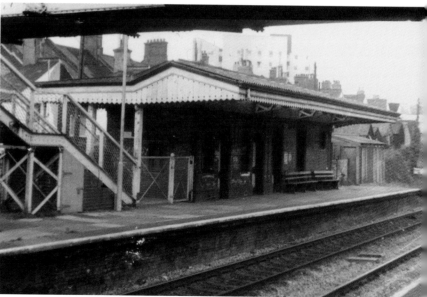

Keyham – The Dockyard Railway

Above: Class '50' locomotive No. 50050 *Fearless* approaches Keyham on 31 May 1978, the trailing connection to the Dockyard branch being visble to the left.

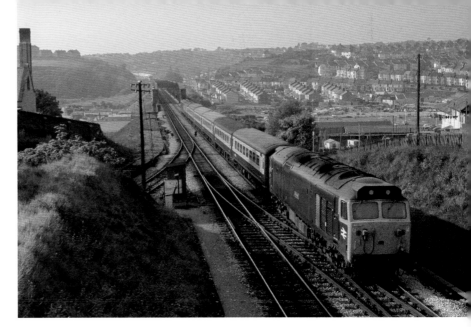

Below: The first locomotive used on the Dockyard Railway was an Aveling & Porter geared locomotive (works No. 143) which, like other engines of this type, was basically a traction engine with flanged wheels. In later years, the dockyard system was typically worked by 0-4-0 saddle tank locomotives from various manufacturers – four-wheeled engines being preferred because of their ability to negotiate the many sharp curves within the Devonport complex. At least eight of these locomotives were Andrew Barclay 0-4-0STs, as shown in the accompanying photograph; they had outside cylinders and characteristic Barclay 'squared-off' tanks. These engines were numbered 9, 10, 11, 13, 16, 17, 18 and 19 (the latter engine later becoming No. 2). Nos 18 and 19, the last to be obtained, were built in 1942 and 1946 respectively, their makers' numbers being 2137 and 2221. They had 3-ft 2-inch wheels and 12-inch by 20-inch cylinders.

In the mid-1950s, the dockyard acquired a fleet of ten four-wheeled 'Planet' diesels from F. C. Hibberd & Co., and these diminutive locomotives worked alongside the 0-4-0ST steam locomotives until May 1966, when the last steam engines were taken out of service. Thereafter, the 'Planets' remained at work in the dockyard for many years, though all had been transferred, scrapped or sold by 1993. The 'Planets' were replaced by Drewry 0-4-0 diesel shunting locomotives Nos 230 and 249, which were transferred from the Army and arrived in the dockyard in March 1993. Both engines were air-braked and, as such, they were able to haul HST sets and other modern passenger and freight rolling stock. The dockyard engines were, for many years, adorned in a standard maroon livery with yellow lining, though the diesels were painted dark green and buffer beams painted in high visibility black-and-yellow stripes. Passenger and freight vehicles were normally light grey with white lettering.

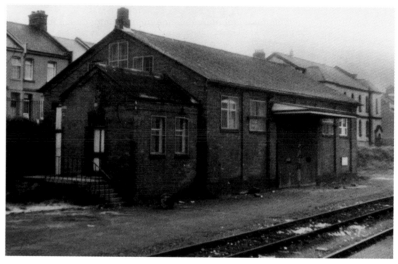

Keyham – The Goods Yard

Above: A detailed study of Keyham goods shed around 1978.

Left: A class '08' diesel shunter stands on the 'Back Platform Line' with a short freight train.

Opposite: Keyham Viaduct

Class '50' locomotive No. 50037 *Illustrious* crosses Keyham Viaduct (247 miles, 55 chains) with the 12.45 p.m. up parcels working from Penzance on 2 April 1979. This service was split on arrival at Plymouth, with traffic going forward to either Paddington or Crewe. Keyham Viaduct was originally a typical Brunelian 'fan viaduct' with seven radiating timber spans resting on masonry piers, but it was rebuilt with iron spans in 1900 – the new girders being supported by the original stone piers, which were heightened by brickwork. The viaduct, some 144 yards in length and 90 feet high, was reconstructed with steel girders in 1937. The picture clearly illustrates the 'two-tone' colouring of the heightened piers, while the distinctive roofline of a Ford Anglia car can be glimpsed over the brick wall in the foreground.

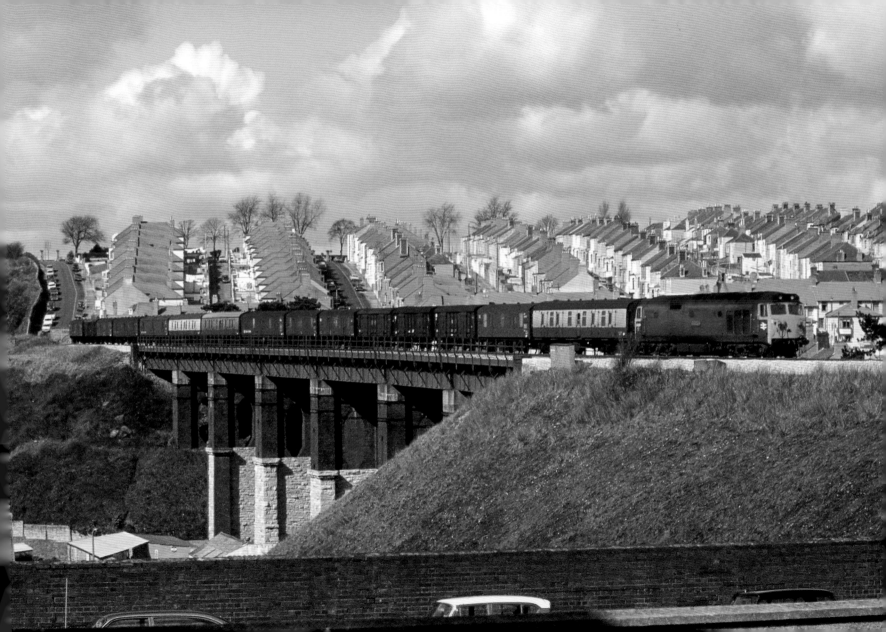

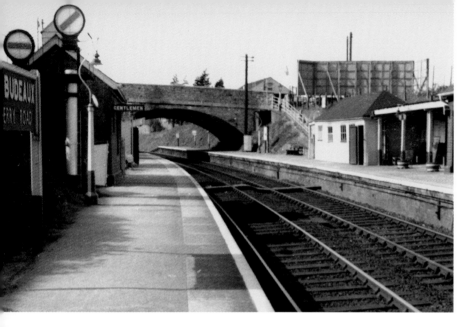

St Budeaux Ferry Road

From Keyham, the route continues northwards to St Budeaux (Ferry Road), where present-day Callington branch trains leave the main line via a wartime link to the former L&SWR system. Since leaving Devonport, the GWR route has been no more than half a mile to the west of the Plymouth, Devonport & South Western Junction line but, as trains approach St Budeaux, the two routes are running side-by-side, the Great Western station (249 miles, 2 chains) being only a few yards from the rival L&SWR station. The South Western station was at one time known as 'St Budeaux (for Saltash)', the name 'St Budeaux Victoria Road' adopted in September 1949, while the neighbouring Western Region station became 'St Budeaux Ferry Road'.

The section of line between Devonport Kings Road and St Budeaux was closed in September 1964, and all remaining services were diverted onto the Great Western line via the Second World War connection, which thereby became the 'main line' for trains proceeding to, or from, the Plymouth, Devonport & South Western Junction route.

The accompanying photographs shows St Budeaux Ferry Road station, which is situated in a grassy cutting that is spanned by a road overbridge. The wartime link to the South Western line, which was brought into use on 23 March 1941, diverges north-eastwards at the south end of the platforms. This emergency connection was laid as a double-track spur with intermediate crossovers to permit greater operational flexibility. In addition to its role as a diversionary route for main line traffic, the wartime connection enabled trains to run between Devonport Dockyard and the PD&SWJR route (and vice-versa) and, in post-war years, there were regular transfer freight workings to and from the dockyard. The wartime connection was reduced to a single track on 7 September 1970, while, at the same time, one-train-on-line working was introduced between St Budeaux and Gunnislake, the single line staff being released remotely by Plymouth Panel Box and obtained from an instrument on the remaining platform at St Budeaux Victoria Road.

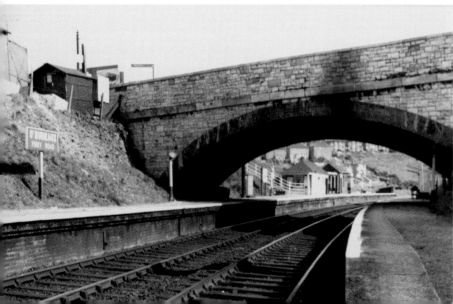

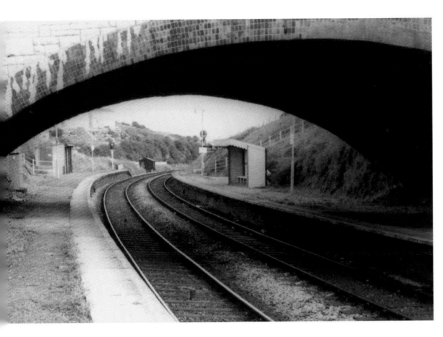

Right: St Budeaux Ferry Road
Class '119' set No. P587 at St Budeaux Ferry Road around 1980. This three-car set comprised motor second No. W51106, trailer buffet second No. W59436 and motor brake composite No. W51078. Introduced in 1958, the class '119' units were intended for use on relatively long-distance routes and, for this reason, some of the sets were provided with buffet facilities.

Left: St Budeaux Ferry Road
A further view of St Budeaux Ferry Road, which is now an unstaffed halt. At one time, there were two signal boxes at St Budeaux, one of these being known as 'St Budeaux West Box', while the other was 'St Budeaux East Box'– the latter having been opened in 1916 to control a short branch to the nearby naval ordnance depot at Bull Point. St Budeaux West Box was destroyed in an air raid on the night of 28/29 April 1941, although the signalman who had been on duty escaped injury as he was outside the box dealing with incendiary bombs. A replacement box was ready for opening by 5 November 1941, but this was closed in June 1952. The neighbouring East Box was then renamed 'St Budeaux Ferry Road Box' and, as such, it remained in use until July 1973, when control was transferred to the Plymouth panel box as part of a resignalling scheme between Plymouth, Laira and Totnes in the east and Keyham and St Germans in the west.

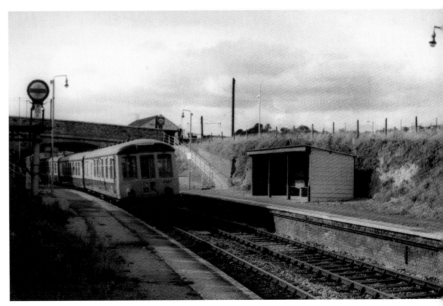

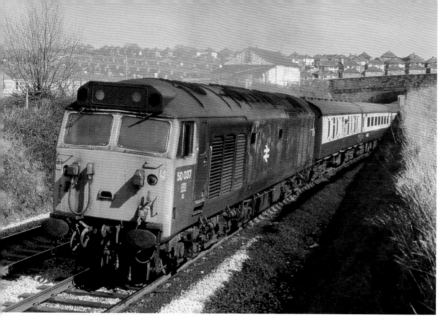

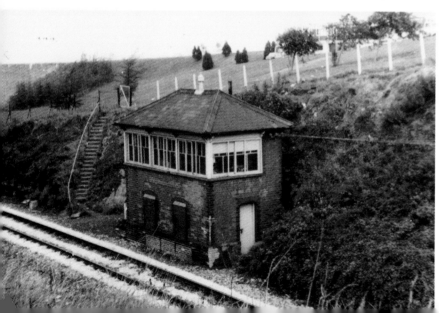

Above: St Budeaux Ferry Road

Class '50' locomotive No. 50037 passes St Budeaux Ferry Road with a westbound working on 16 April 1978. The oil-soaked and scruffy locomotive would have been largely ignored by railway enthusiasts at that time. However, interest in the class started to increase once the locomotives received their evocative 'warship' names and, in this context, No. 50037 received its *Illustrious* nameplates a few weeks after this photograph was taken.

Below: Royal Albert Bridge Signal Box

Heading north-westwards, trains approach the mighty Royal Albert Bridge, which is built upon a slight curve, and carries just one line of rails. Royal Albert Bridge Signal Box was situated on the east side of the bridge to control the double to single line junction. The box, which dated from the early years of the twentieth century, was a typical Great Western structure, with a hipped roof and distinctive five-pane windows. In later years, it contained a 25-lever frame. Hip-roofed boxes of this same general type were built in large numbers after about 1896. Royal Albert Bridge Box was taken out of use as part of the 1973 Plymouth resignalling scheme.

Opposite: Saltash – The Royal Albert Bridge

With the whitewashed houses of Saltash in the background, class '50' locomotives Nos 50008 *Thunderer* and 50015 *Valiant* slowly negotiate the Royal Albert Bridge with the Pathfinder Tours 'Cornish Centurion 2' rail tour on 4 May 1991. The tour was returning to Manchester Piccadilly, after visiting the Drinnick Mill and Fowey branch lines.

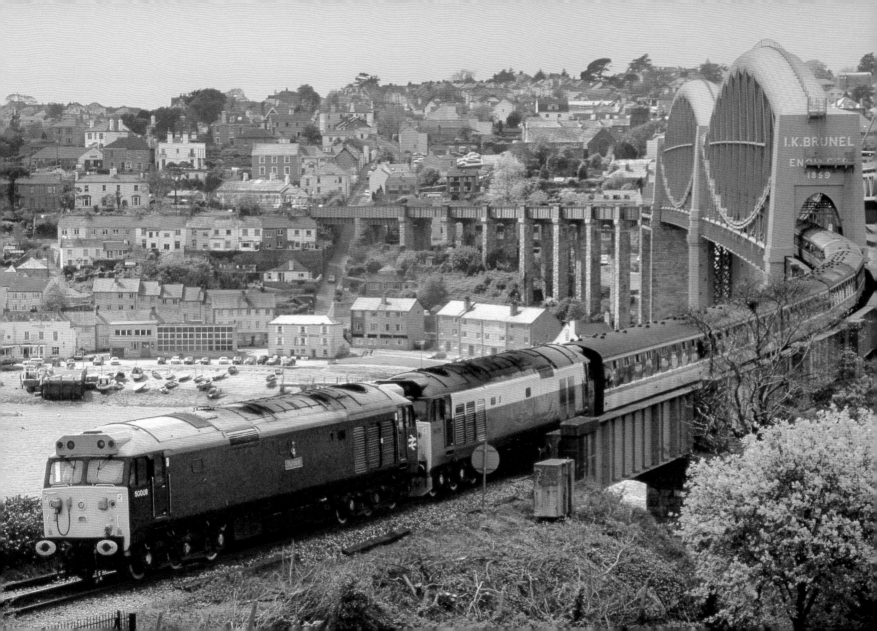

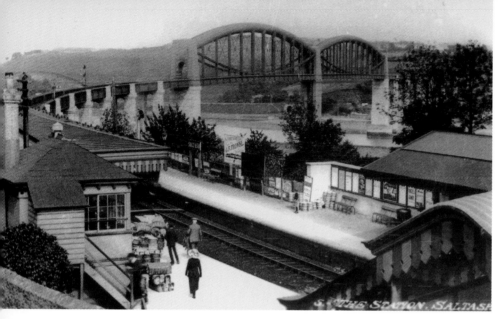

Saltash – The Royal Albert Bridge

Above: On gaining the Cornish side of the Tamar, westbound trains enter Saltash station (250 miles, 13 chains). This still-extant stopping place was opened by the Cornwall Railway on 4 May 1859, and it marked the end of the Plymouth suburban area – although a handful of local trains had continued westwards to Defiance platform until the closure of that stopping place in 1930. This Edwardian postcard is looking north-eastwards around 1908. Saltash Signal Box is visible in the foreground, while the famous bridge dominates the background.

Below: A view of the Royal Albert Bridge from Lower Fore Street. Having initially suggested that a timber bridge might be constructed, Brunel decided that the Tamar would be spanned by a wrought-iron bridge with two main spans, each 455 feet, and seventeen-plate girder approach spans. The two main trusses, weighing 1,000 tons apiece, were fabricated on the river bank and then floated into position on pontoons – hydraulic jacks being employed to raise the completed trusses into position.

The first truss was successfully floated on 1 September 1857, the spectacle being watched by as many as 50,000 people. The *Royal Cornwall Gazette* reported that: 'The sight of the gigantic structure gliding so gracefully from its resting place by the waters of the Tamar, by means apparently so simple because so silently applied, but yet, on examination so complicated and multifarious, was indeed one which will long be remembered by those who had the good fortune to witness it.' The operation was accomplished in little more than two hours, after which the Cornwall Railway directors and their VIP guests sat down to a 'bountiful luncheon' in one of the storehouses on the Saltash side of the river.

The second truss was floated into place on 10 July 1858 and, both trusses having been raised at the rate of 6 feet per week, Brunel's great bridge was ceremonially opened by Prince Albert on Monday 2 May 1859. Brunel died in the following September, and his name was then inscribed on the piers at each end of the bridge as a permanent memorial.

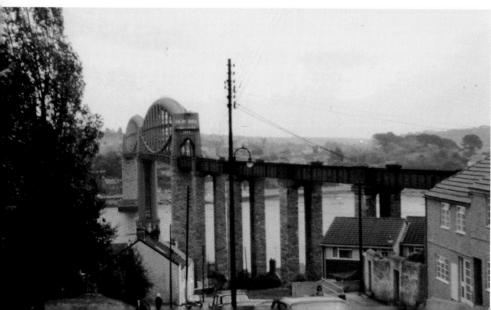

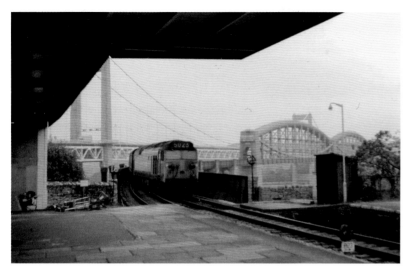

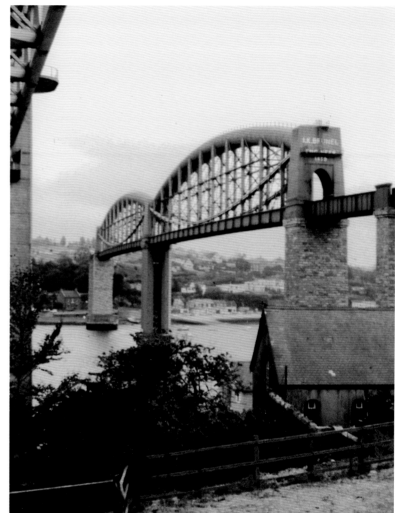

Saltash – The Royal Albert Bridge

An unidentified class '50' locomotive creeps across the bridge with a down passenger working. The road bridge that can be seen in the background was opened in 1961. A strict speed limit is in force across the bridge, but this adds to the drama and sense of occasion as trains cross from England into Cornwall to the accompaniment of an echoing metallic rattle. In her book *Vanishing Cornwall* (1967), Daphne du Maurier (1907–89) vividly recalled the first time that she crossed the Tamar as a very young child. Having been told to close her eyes until the train had reached Cornwall, she cheated and opened them: 'There was nothing to see, only chinks of water between what seemed to be iron bars, and the rattle of the train made a frightening sound. One moment there was light, the next darkness, then light, then darkness again. I was bewildered, and the few moments seemed like hours. Suddenly the rattle ceased, and the wheels changed their tune. Everything was light, and the sun streamed through the carriage window.'

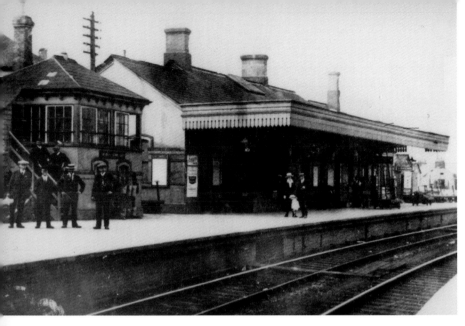

Saltash – The Station Building

Above: The main station building, on the up platform, is a single-storey Italianate-style structure with tall chimneys and a projecting platform canopy. Similar buildings were provided at most of the smaller Cornwall Railway stations between Plymouth and Falmouth, and they were clearly a standard design. Although of obvious 'Brunelian' appearance, the designer was probably Peter John Margary (1820–96) the Cornwall Railway engineer, who had trained under William Gravatt, who had in turn been trained by Brunel. This Edwardian postcard dates from around 1910.

Below: A further postcard view, looking west towards Penzance during the early years of the twentieth century. It is interesting to note that when the Cornwall Railway was first opened, pedestrians were able to purchase a 3*d* ticket from the booking office at Saltash station that allowed them to walk across the Royal Albert Bridge.

Opposite: Saltash
Steam railmotor car No. 7 stands in the up platform at Saltash during the early 1900s. This vehicle was built at Swindon in 1904, as one of a batch of six railmotors numbered from 3 to 8.

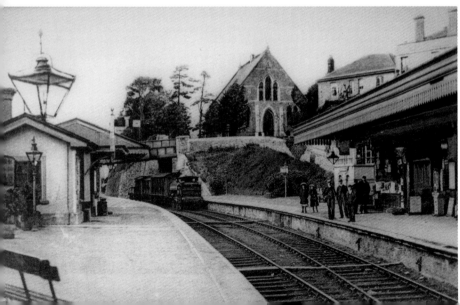

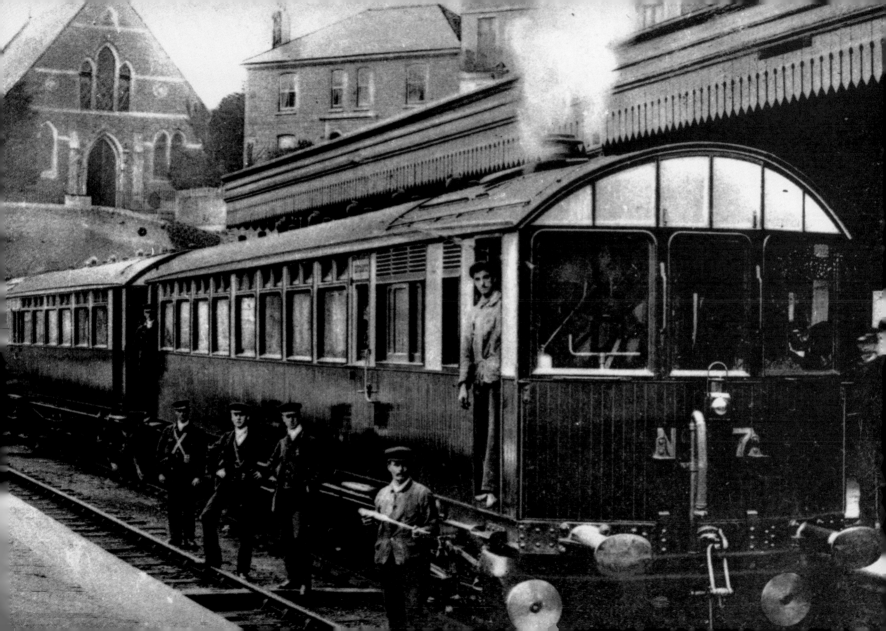

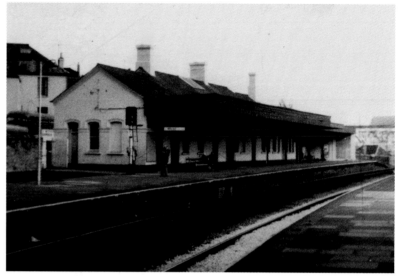

Saltash – The Station Building & Goods Shed

Above: A detailed view of the main station building, photographed by Mike Marr around 1980. This building is still in situ, although Saltash is now an unstaffed halt.

Left: A close-up view of the substantial, stone-built goods shed, taken after the cessation of freight traffic. The 1938 Railway Clearing House *Handbook of Stations* reveals that Saltash was able to deal with a full range of freight traffic, including coal, livestock, furniture, horse boxes, vehicles and general merchandise, while a 2-ton crane was available for loading or unloading large or bulky consignments.

Saltash

Right: A general view of the station, looking north-eastwards along the up platform during the British Railways period around 1960.

Below right: A ferry was in operation at Saltash in pre-Norman times, the earliest ferries being propelled by oars. Chain-guided steam ferries were introduced during the early nineteenth century, the very last ferry being built by Messrs J. T. Thorneycroft of Southampton in 1933. The ferry became redundant following the opening of the Tamar road bridge, and the service was officially withdrawn on 23 October 1961.

Below left: An Edwardian postcard scene, showing the road overbridge at the west end of the station; the connection that can be seen just beyond the arch gave access to the goods yard, which was situated on the up side of the running lines.

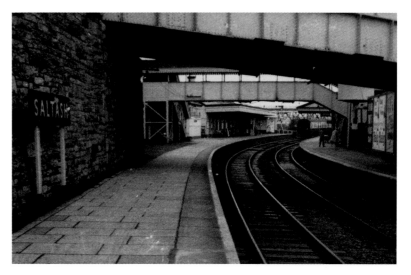

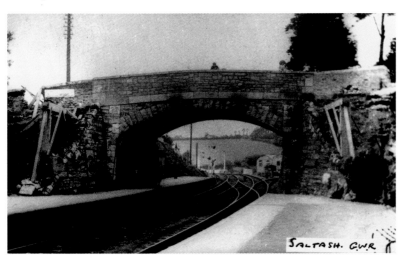

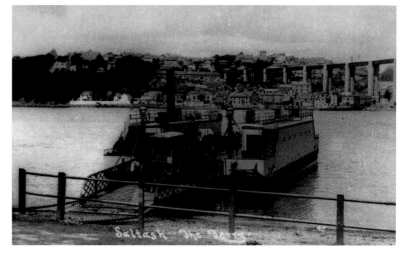

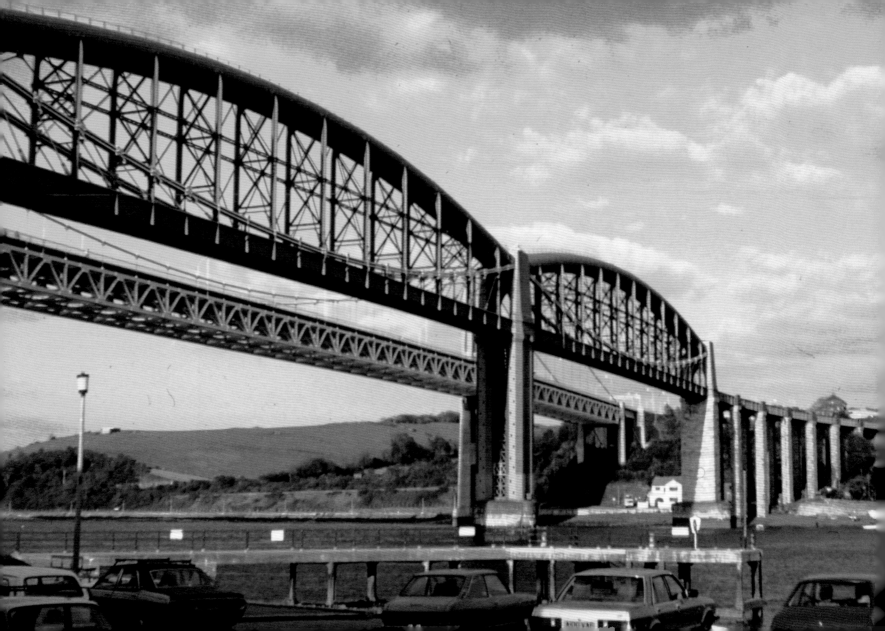

Defiance Platform

Above: Defiance Platform (251 miles, 7 chains), a short distance beyond Saltash, was opened on 1 March 1905, principally for use by sailors attending the torpedo training school aboard the veteran wooden battleship HMS *Defiance*, which was moored at nearby Wearde Quay. As originally constructed, the section of line between Saltash and St Germans was plagued by sharp curvature and gradients as steep as 1 in 75. It was therefore decided that the line would be rebuilt on a new alignment, the deviation being ready for goods traffic by 23 March 1908, while passenger trains started using the new, double-track line on 31 May 1908.

The improvement scheme involved the re-siting of Defiance Platform and the elimination of five timber viaducts – Forder, Nottar and St Germans viaducts being replaced by double-track, masonry viaducts, while Wiviliscombe and Grove viaducts were eliminated altogether. The re-sited Defiance Platform boasted typical Great Western 'pagoda' buildings, while its modest track layout included a down goods loop and two carriage sidings for use in connection with terminating local trains. It is interesting to note that a section of the original main line remained in use as a siding.

Below: Class '50' locomotive No. 50028 *Tiger* passes the site of Defiance Platform with the 4.40 p.m. St Erth to Acton milk train on 13 May 1979. Defiance Platform was closed to regular traffic in 1930, although the signal box remained in use until October 1965.

Opposite: **Saltash – The Royal Albert Bridge**

This final view of Brunel's masterpiece, taken in May 1984, accentuates the height of the bridge, necessary because the Admiralty had insisted on a headroom of at least 100 feet for vessels passing underneath. The approach spans were renewed in 1928, while the main spans were strengthened in the 1960s, when twenty-four diagonal steel ties were added to each span as part of an improvement programme that started in 1967 and was completed in 1969.

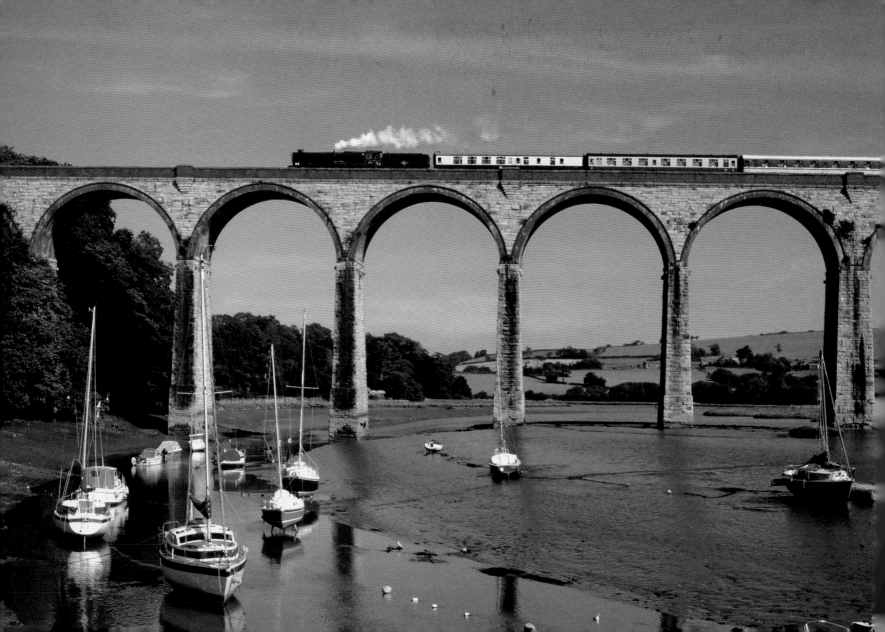

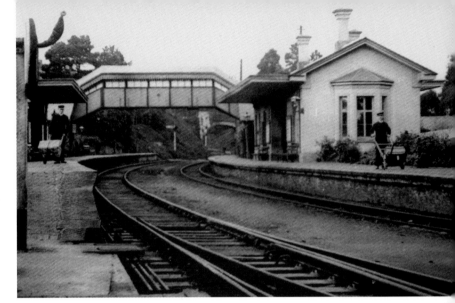

Above: St Germans – The Station Buildings

Situated just beyond St Germans Viaduct, St Germans station (255 miles, 14 chains) was opened on 4 May 1859. The photograph is looking west towards Penzance around 1912, the main station building being on the up platform, to the right of the picture. This characteristic Cornwall Railway structure is a single-storey Italianate-style building with three tall chimneys and a low-pitched gable roof. The front of the building is slightly recessed to form a *loggia* beneath the full-length platform canopy, and the recessed portion is about 18 ft long. The up and down platforms are linked by a plate girder footbridge, while a slightly smaller building is provided on the down side. Although still extant, these two buildings are no longer used for railway purposes, the up side building having been adapted for use as a private dwelling.

Below: St Germans – The Main Station Building

A detailed look at the main station building, showing the above mentioned *loggia*. Internally, the building contained the usual booking office, waiting room and public toilet facilities. In the late 1990s, the occupants of the station placed a camping coach in the former loading dock to the east of the building, this ex-London & South Western passenger luggage van being opened to the public in 1998. The venture was so successful that two further vehicles were acquired – a GWR travelling post office and a GWR slip carriage. The TPO van is parked in the old loading dock in place of the luggage van, which has been moved to the west end of the site. The slip coach, known as *Mevy*, rests in a landscaped garden.

Opposite: St Germans Viaduct

'King' class locomotives No. 6024 *King Edward I* crosses St Germans Viaduct (254 miles, 61 chains), with the 5.30 p.m. Pathfinder Tours Paddington to Penzance 'Penzance Pirate' rail tour on 19 September 1998. The tree-lined banks of the River Tiddy and the anchored yachts epitomise the balmy, sub-tropical atmosphere of southern Cornwall. The viaduct has thirteen arches, each with a span of 64 feet and a total length of 300 yards.

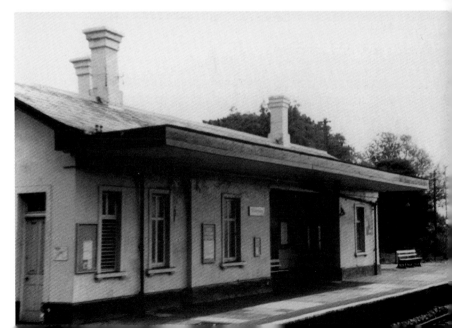

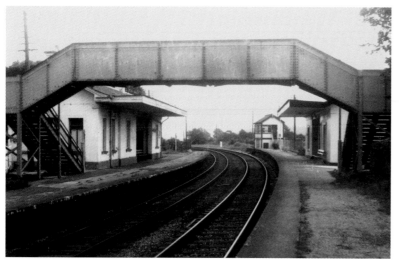

St Germans

Left: A general view of St Germans station, looking east towards Paddington during the early 1960s. The signal box was a timber-built cabin sited to the east of the platforms on the down side. It was closed in 1973, but control of the section was then transferred to a panel located within the main station building, an arrangement that lasted until April 1998.

Below left: The down side station building around 1980, looking east towards Paddington.

Below right: The western extremity of the platforms, looking towards Penzance during the 1960s.

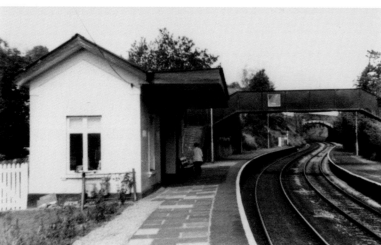

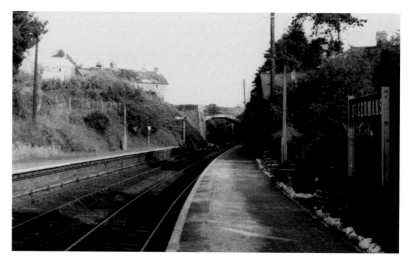

Above: St Germans – The Down Station Building
This final photograph of St Germans provides a detailed view of the
down side station building.

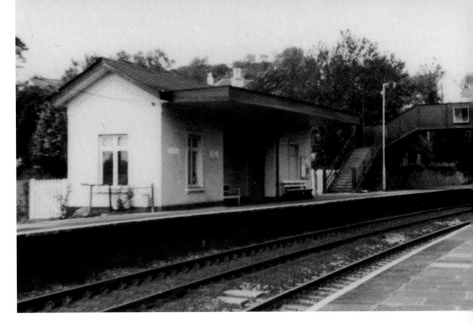

Below: Menheniot – The Signal Box
Turning onto a north-westerly alignment, the railway climbs at 1 in 76
for a distance of around 2 miles, beyond which the route becomes more
or less level on the approach to Tresulgan Viaduct (259 miles, 69 chains).
Like other viaducts en route to Penzance, this was originally a timber
structure, but it was rebuilt with masonry arches in 1897. Resuming their
ascent, trains then cross the lofty Coldrennick Viaduct (260 miles, 29
chains), which was rebuilt with iron girders in 1897 and renewed with
steel spans in 1933.

Menheniot station (260 miles, 47 chains) was opened on 4 May
1859. Its facilities included a classic Brunel designed 'chalet'-type station
building, with a timber-framed structure on the down platform. The
up platform was equipped with a somewhat smaller, Italianate-style
waiting shelter, while the up and down platforms were linked by a
plate girder footbridge. Menheniot Signal Box was a gable roofed cabin
with small-paned windows; boxes of this type were erected all over the
GWR system until the mid-1990s, when the Great Western introduced
a modified design with a hip-roof and five-pane windows (as shown on
page 30).

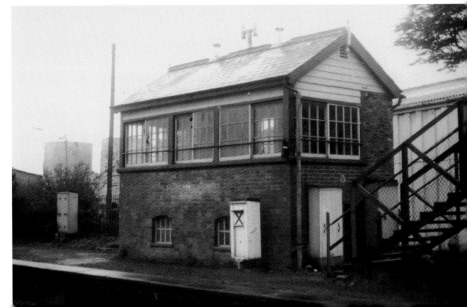

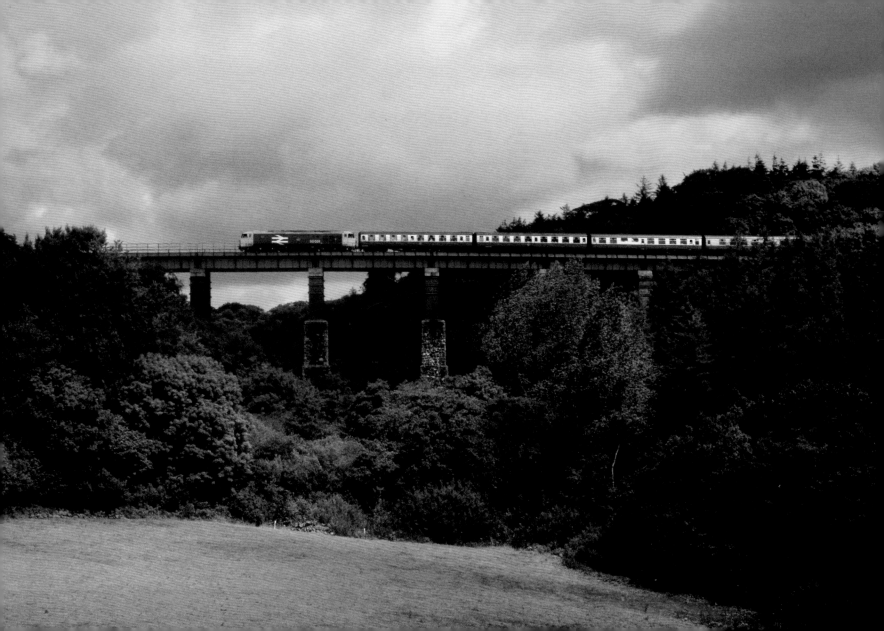

Liskeard

Heading north-westwards on rising gradients of 1 in 78 and 1 in 74, trains cross a series of four viaducts. Trevido, Cartuther and Bolitho viaducts have been rebuilt with masonry arches, whereas Liskeard Viaduct (263 miles, 36 chains) was reconstructed with iron girders in 1894 and rebuilt with steel spans in 1926.

Liskeard station (263 miles, 56 chains), the junction for branch services to Looe, was opened on 4 May 1859. The Looe branch is surely one of the most eccentric lines in operation. Built to transport copper ore from Caradon mines to the sea, it was opened as a canal and rebuilt as a railway in 1860. A passenger service was inaugurated on 11 September 1879, while on 15 May 1901 the line was linked to the Great Western system at Liskeard. Eight years later, on 1 January 1909, the GWR began working the line, although the Liskeard & Looe Co. remained nominally independent until the grouping of railways in 1923.

Looe branch trains depart from a special platform built at right angles to the main line platforms, and head north-eastwards for a quarter of a mile. Rounding a 180-degree curve, the direction of travel then changes to the south-west, and the single line branch falls sharply beneath Liskeard Viaduct in order to reach Coombe Junction, some 150 feet below. Local people say that, if one misses the train at Liskeard, it is possible to run down Lodge Hill and catch it at Coombe. Having arrived at Coombe facing northwards, the train reverses before setting off along the picturesque line to Looe.

The upper view shows an unidentified '3521' class 4-4-0 beside the up platform at Liskeard, while the lower photograph, taken on 3 July 1963, shows the main station building, which is situated at road level on top of the cutting.

Opposite: Liskeard–Coldrenick Viaduct

Class '50' locomotive No. 50031 *Hood* crosses Coldrenick Viaduct with the 7.18 a.m. Paddington to Penzance 'Cornubian' rail tour on 18 July 1998.

Right: Liskeard – The Looe Branch Platform

A further view of the branch platform, looking south towards the main line platforms during the 1960s. The Looe branch was worked by steam locomotives until the start of the winter timetable on 11 September 1961, when the branch passenger services were dieselised, while freight workings were soon taken over by North British 'D63XX' class locomotives. In recent years, the Liskeard to Looe route has typically been worked by class '150' diesel multiple units.

Left: Liskeard – The Looe Branch Platform

This detailed view of the Looe branch platform is looking north during the early 1960s. A '45XX' class 2-6-2T is running round its train. Introduced in 1906, the '45XX' class 2-6-2Ts were a development of the slightly earlier '44XX' class, with 4-ft 7½-inch coupled wheels and increased boiler pressure. These 'small prairies' were widely used on West Country branch lines such as the Looe, Falmouth and St Ives routes. They remained in use until the 1960s, and fourteen examples have survived as preserved engines on 'heritage' lines; the engines concerned are Nos 4555, 4561, 4566, 4588, 5521, 5526, 5532, 5538, 5539, 5541, 5542, 5552, 5553 and 5572.

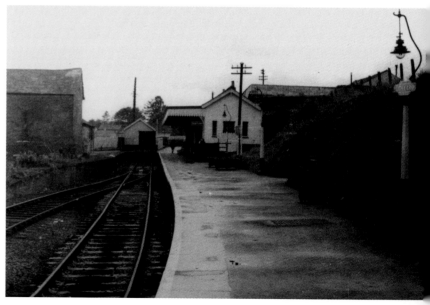

Liskeard

Right: A general view of Liskeard station, looking east towards Paddington along the rain-swept platforms, on the morning of 21 September 1983. The main station building can be glimpsed above the cutting on the extreme left of the picture.

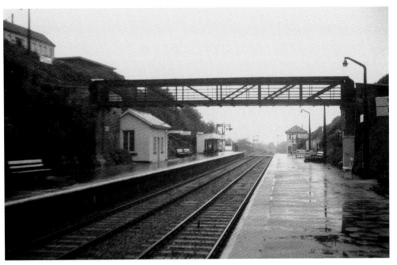

Below Right: The weather eventually improved, as shown in this photograph of a class '121' single unit railcar waiting in the Looe branch platform, which was taken later on the same day.

Below Left: A glimpse of the down platform during the early 1930s.

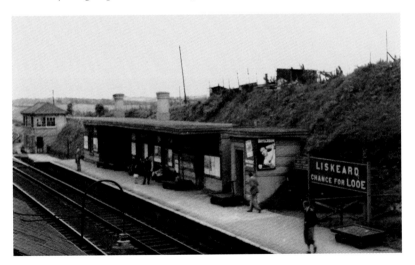

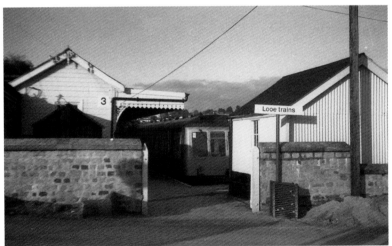

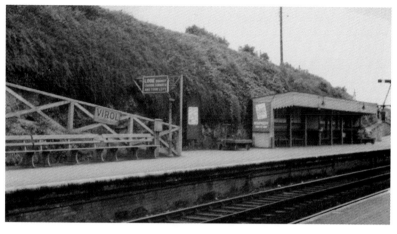

Liskeard

Left: The up platform on 30 August 1951.

Below left: The signal cabin was an all-timber version of the usual Great Western hip-roofed design.

Below right: A further view of the main station building.

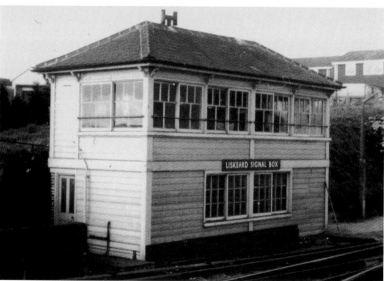

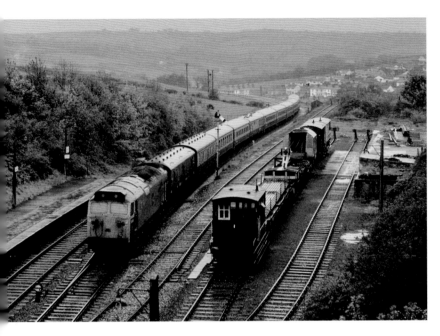

Left: Liskeard

Class '50' locomotive No. 50047 *Swiftsure* enters Liskeard station with an up passenger working on 30 May 1979. Semaphore signals are still in use at this location, although the engineers' sidings seen on the right of the picture have now been lifted.

Right: Liskeard – Moorswater Viaduct

Moorswater Viaduct (264 miles, 25 chains) is situated immediately to the west of Liskeard station. In common with the other major viaducts between Plymouth and Penzance, it was originally of timber construction, but now consists of eight masonry spans – the old timber 'fan' structures were replaced in 1881. The photograph was taken from the south around 1980. The single line running beneath the viaduct is the former Liskeard & Caradon Railway, which continued northwards to reach the mines and quarries around Caradon and the Cheesewring.

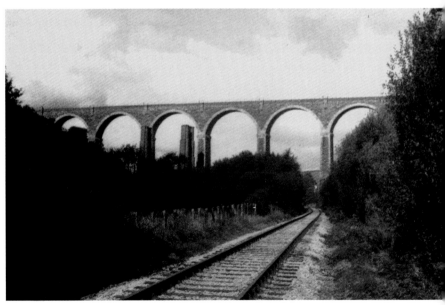

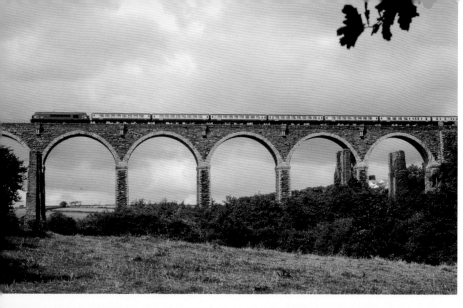

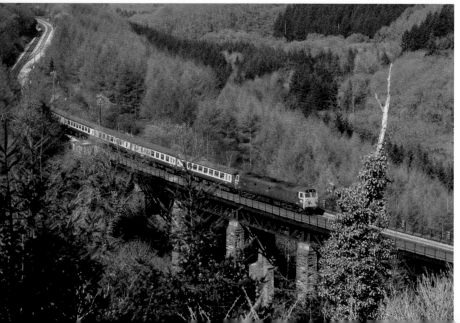

Above: Liskeard – Moorswater Viaduct

A brief glimpse of sunshine against a stormy sky as class '46' locomotive No. 46025 crosses Moorswater Viaduct with a westbound working on 28 July 1978. Note the piers of the original viaduct both to the left and the right of the picture.

Below: East Largin Viaduct

Heading westwards, trains cross viaduct after viaduct, all of which were originally built of timber, with stone piers. The nine-span East Largin Viaduct (268 miles, 56 chains) was reconstructed with wrought-iron girders in 1886, the snecked stone piers being raised to take the place of Brunel's raked timber 'fans'. The photograph shows class '50' locomotive No. 50028 *Tiger* crossing the viaduct with an unidentified eastbound working on 18 April 1979. Clearly visible in the background are the two tracks merging into a single track to cross the viaduct. Photography is made difficult at this location by the plantations of coniferous trees on both sides of the valley of the river.

Opposite: St Pinnock Viaduct

Class '47' locomotive No. 47481 crosses St Pinnock Viaduct (268 miles, 27 chains) at the head of the 7.30 a.m. Paddington to Penzance service on 18 April 1979. With a height of 151 feet, this is the tallest viaduct in Cornwall; it has eight spans and a total length of 312 yards. The slender stone piers have six stages, with pointed, Gothic-style openings. The uppermost stages were added in 1882 when Brunel's original timber 'fans' were replaced by iron girders.

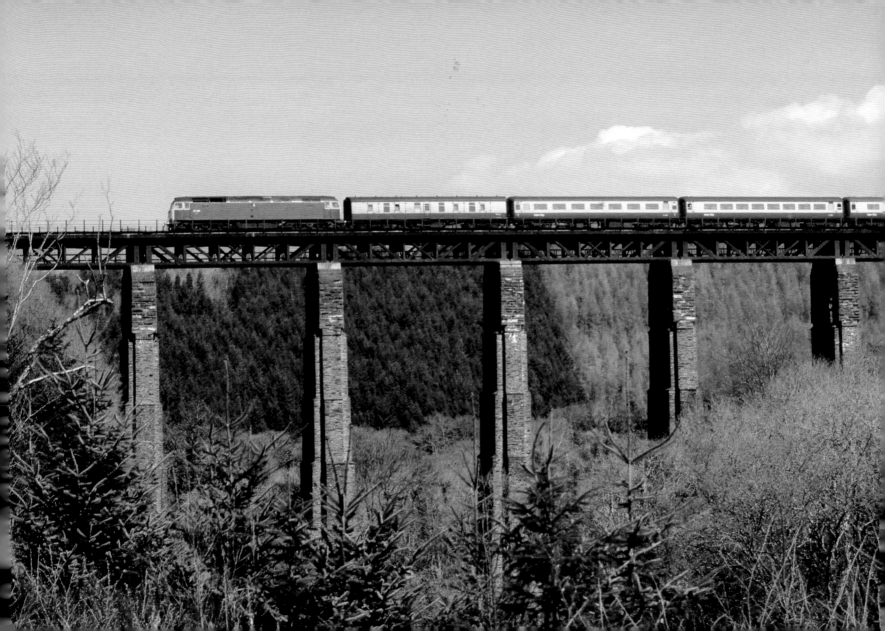

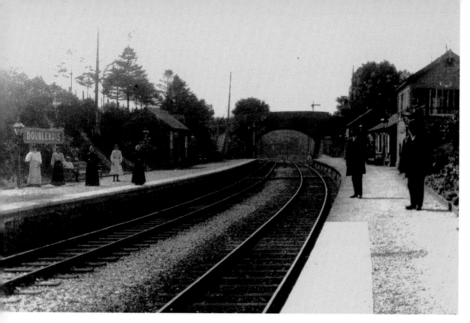

Doublebois

Heading westwards on gradients as steep as 1 in 61 the route approaches its summit at Doublebois (267 miles 0 chains), a small station opened on 1 June 1860 and closed with effect from Monday 5 October 1964. Up and down platforms were provided here, the main station buildings being on the up platform, while a minor road was carried across the line on a single-arched bridge at the west end of the station. The upper view is looking west towards Penzance during the early 1900s, while the lower photograph was taken from a similar vantage point around sixty years later.

Passenger traffic at Doublebois was relatively healthy, with around 15,000 tickets being issued per annum during the Edwardian period. The number of ordinary single or return tickets issued each year had declined to around 10,000 per year by the 1920s, but this apparent decline can be explained by an increase in the number of season tickets purchased by regular travellers. In 1931, for example, the station issued 11,362 ordinary tickets together with thirty season tickets, while, in the mid to late 1930s, the number of season ticket holders averaged around 40.

The amount of goods traffic handled at fluctuated between 8,000 and 17,600 tons per annum during the first three decades of the twentieth century, though, in 1931, goods traffic amounted to 38,318 tons, most of this being in the form of incoming mineral traffic, presumably probably roadstone or building materials.

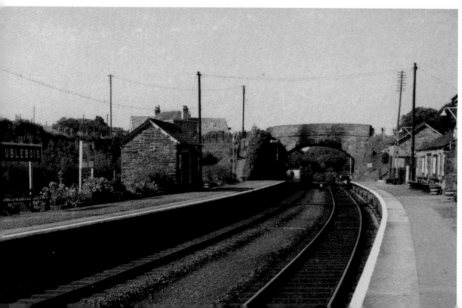

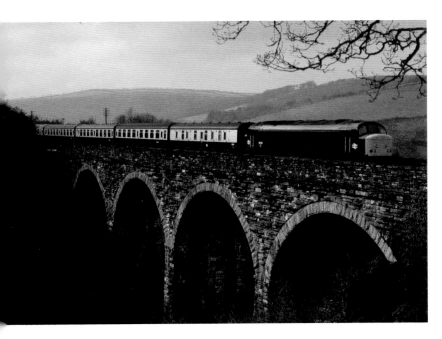

Right: Bodmin Parkway and the Bodmin & Wenford Railway

Bodmin Parkway (272 miles, 69 chains) is an attractive GWR country station situated in picturesque, woody surroundings. The station was opened by the Cornwall Railway in 1859, and it became a junction on 27 May 1887 when the GWR opened a short branch line to Bodmin. On 3 September 1888, the Bodmin line was linked up to the Bodmin & Wadebridge route at Boscarne Junction, and by this means branch trains were able to run through to Wadebridge and Padstow. Passenger services between Bodmin Road, Bodmin, Wadebridge and Padstow were withdrawn with effect from 30 January 1967 and, as this was a Monday, the last trains ran on Saturday 28 January 1967. However, the Bodmin & Wenford Railway was subsequently re-opened as a preserved line between Bodmin Road and Boscarne Junction, using a mixture of steam and diesel power, while Bodmin Road station has remained in operation as Bodmin Parkway.

Left: Doublebois–Derrycombe Viaduct

Having surmounted its summit at Doublebois, the railway descends along the Fowey Valley on falling gradients as steep as 1 in 67 and 1 in 58, as trains cross a succession of impressive viaducts, one of these being Derrycombe Viaduct (269 miles, 62 chains), which was built in 1881 to replace an earlier Brunel 'fan viaduct'. The photograph shows class '45' locomotive No. 45063 crossing the viaduct with a westbound working on 18 April 1979.

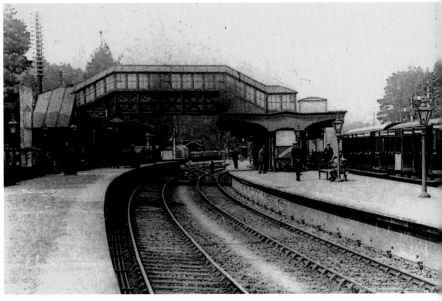

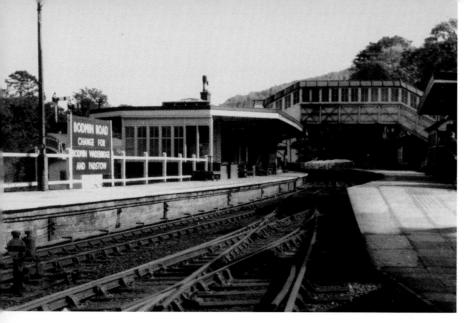

Bodmin Parkway – Goods Sidings and Other Infrastructure

The station occupies a restricted site in a narrow valley, and for this reason its junction facilities are relatively compact. The layout provides three platform faces, the up platform being an island with an additional face for branch workings. The station has been partially rebuilt with new station buildings, although the traditional GWR covered footbridge has been retained. Similarly, the signal cabin, although no longer used for signalling purposes, has found a new lease of life as a café for tourists and waiting travellers. The Bodmin branch joins the up running line at the east end of the up platform, and there is a cluster of dead-end sidings at the west end of the station.

Prior to rationalisation, there had been a small goods yard on the down side, and this had contained the usual broad gauge style goods shed, together with coal wharves, a cattle dock, and an end-loading platform – the latter being sited at the end of the down platform and reached via a short kick-back spur from the main goods sidings. The 1938 Railway Clearing House *Handbook of Stations* shows that there were, at that time, two private sidings in the vicinity of the station, both of these associated with Cornwall's important China Clay industry. The Cornish Kaolin Co. had a siding at the station, but the Great Hawk's Tor China Clay Co.'s siding was situated to the east of the station in the direction of Doublebois. Bodmin Road handled about 3,000 tons of freight per year during the Edwardian period, while, in the 1930s, the station dealt with up to 33,000 tons of freight per annum. In 1938, for example, the total freight traffic amounted to 30,273 tons, most of this China Clay traffic from the Cornish Kaolin siding or the Black Hawk's Tor China Clay siding.

The upper picture is looking east towards Paddington during the 1960s, while the colour photograph shows class '47' locomotive No. 47812 arriving at Bodmin Parkway, with the 8.48 a.m. Penzance to Manchester Piccadilly Virgin Cross Country service, on 24 October 2000.

Opposite: Bodmin Parkway

Class '50' locomotives Nos 50033 *Glorious* and 50007 *Sir Edward Elgar* pull away from the station with the 4.15 p.m. Penzance to Plymouth 'Royal Duchy' rail tour on 26 September 1993. By special arrangement, sister engine No. 50042 *Triumph* stands in the Bodmin & Wenford Railway's bay platform with a connecting service to Bodmin General.

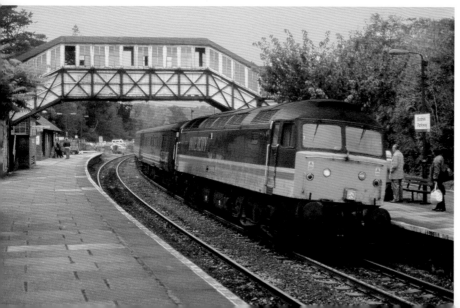

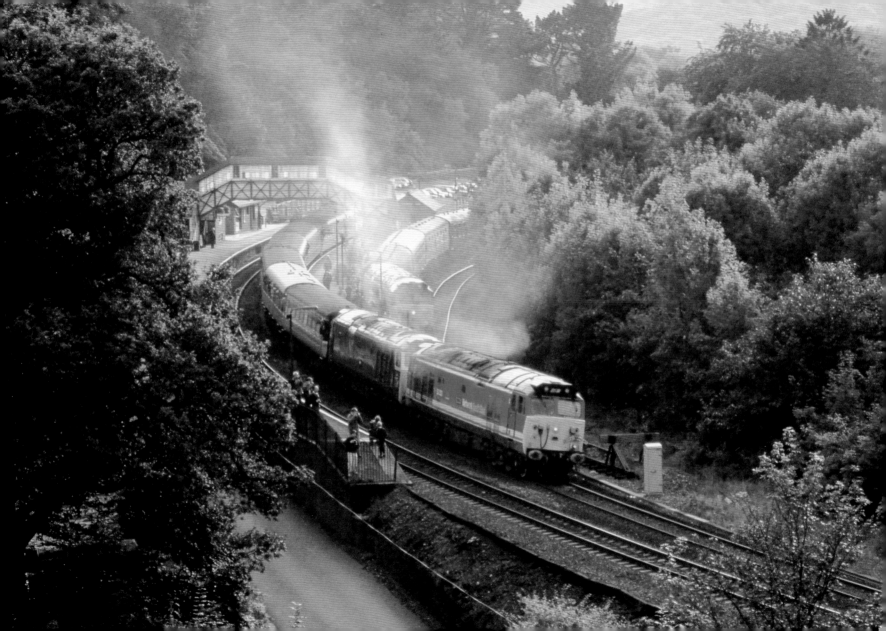

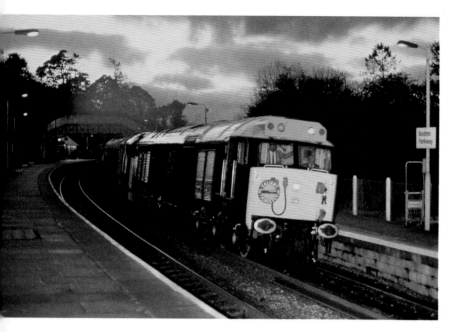

Right: Bodmin Parkway – Bodmin & Wenford Motive Power

Class '52' locomotive No. D1048 *Western Lady* receives some much needed cosmetic attention in the Bodmin & Wenford sidings, at Bodmin Parkway on 23 November 1991. Like other 'heritage' lines, the Bodmin & Wenford Railway is worked by a range of locomotive types, some of which have been loaned or hired from other preserved lines. In recent years, the line has been worked by '14XX' class 0-4-2T No.1450, '45XX' class 2-6-2T No. 5541, and Hawksworth '15XX' class 0-6-0PT No 1501. At other times trains are hauled by various industrial saddle tanks, or by preserved diesels. The appearance of No. 5541 was particularly appropriate in view of the line's long association with the '45XX' class, but an even more appropriate locomotive was used on the branch in August 1996, when '1366' class 0-6-0PT No. 1369 (formerly shedded at Wadebridge) returned to its old haunts.

Left: Bodmin Parkway – The Valiant Thunderer Rail Tour

Shortly after sunset on 23 November 1991, class '50' locomotives Nos 50008 *Thunderer* and 50015 *Valiant* pass through Bodmin Parkway, with the 2.20 p.m. Newquay to Manchester Piccadilly 'Valiant Thunderer' rail tour. Geoff Hudson, the BR area fleet manager who did so much to maintain the class '50's during their last years at Laira, can be seen standing inside *Thunderer's* cab. Bodmin Road was never a particularly busy station in terms of passenger traffic, though its traffic statistics were remarkably consistent for many years. In 1903, 12,336 tickets were issued, whereas, in 1932 and 1936, the station issued 12,681 and 11,087 tickets respectively. These figures suggest a slight decline, though when one considers that there were between forty and fifty regular season ticket holders during the 1930s, it will be seen that the actual number of journeys being made was fairly constant at about 12,000 per annum. In 2011/12, this Cornish station generated 248,220 passenger journeys.

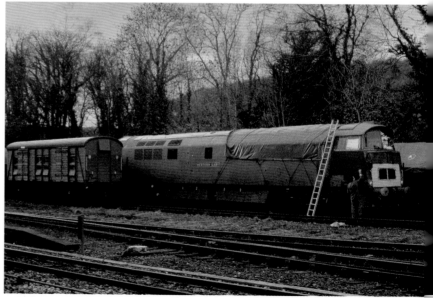

Above: Lostwithiel Passing Restormel Castle

On leaving Bodmin Parkway, the railway pursues a winding course between steep, wooded hillsides, the gradients on this section being generally favourable to westbound services, apart from a short ascent on the approach to Brown Queen Tunnel. Restormel Castle is briefly visible on the right-hand side of the line, after which trains slow for the approach to Lostwithiel (276 miles 22 chains). The photograph, taken on 29 July 1978, shows class Swindon '120' unit No. C558, comprising of motor second No. 51588, trailer buffet second No. 59588 and motor brake composite No. 51579, passing Restormel Castle with a westbound service on 29 July 1978. The class '120' units are now extinct, apart from a solitary trailer buffet car that has survived.

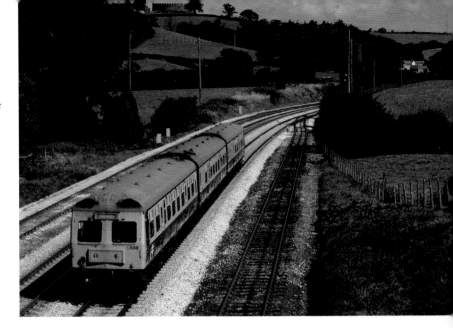

Below: Lostwithiel – The Fowey Branch

Opened as a wayside station on the Cornwall Railway on 4 May 1859, Lostwithiel was one of the most attractive stopping places on the West of England main line. Situated beside the tranquil River Fowey, and surrounded by beautiful woodland scenery, the station was of classic Great Western design, its timber-framed buildings being fully within the 'Brunelian' tradition.

The Fowey branch, which diverges on the down side of the main line, has a chequered history. The Lostwithiel & Fowey Railway was opened for mineral traffic between Lostwithiel and Carne Point on 1 June 1869, but the venture was not a success, and this broad gauge branch was closed in 1880. However, on 16 September 1895, the GWR reopened the branch as a 5¼-mile standard gauge route and, for the next sixty-nine years, the Fowey branch carried both passengers and freight traffic. Sadly, passenger services ceased on Saturday 2 January 1965, but the Fowey line has remained in operation in connection with China Clay traffic.

The track layout at Lostwithiel grew steadily throughout the years, until, by the 1930s, the station was surprisingly complex. In addition to the three platform roads and goods yard, there were up and down goods loops, together with a number of marshalling sidings for China Clay traffic, and a rail-connected milk depot on the up side. The milk depot, which had been installed around 1932 to serve a Nestlé milk depot, received milk from the surrounding area for despatch to London in glass-lined tank wagons. The up and down platforms were linked by a plate girder footbridge – the latter structure being roofed in typical Great Western fashion. At night, the platforms were illuminated by traditional gas lamps, though electric lights on concrete posts were erected during the BR era.

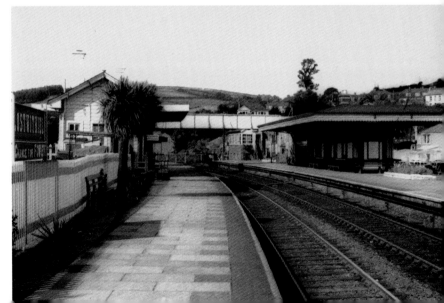

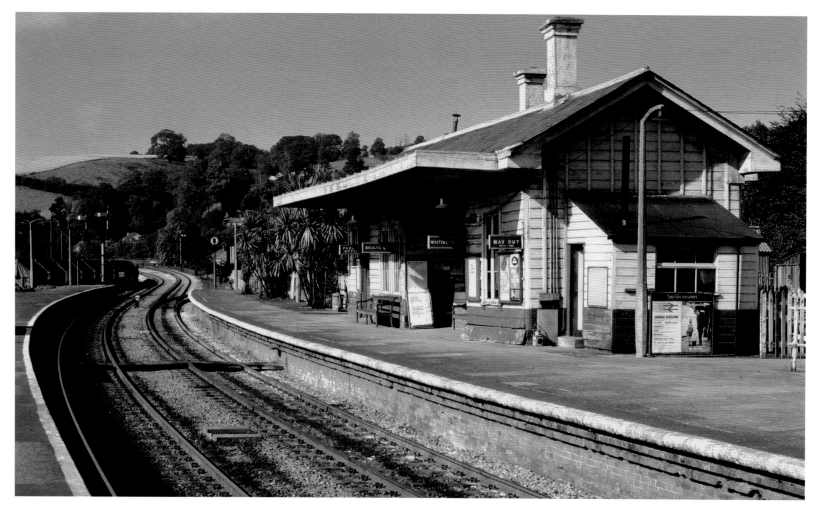

Lostwithiel

The main station building basks in the summer sunshine on 29 July 1978. This building was erected by Messrs Oliver & Sons of Falmouth, a well-known Cornish building firm.

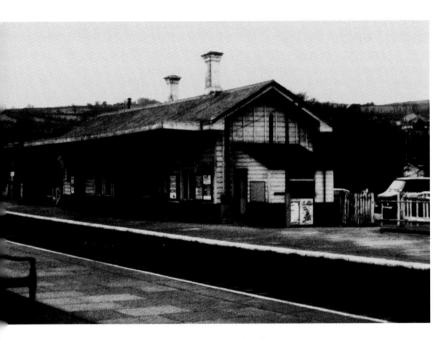

Left: Lostwithiel – The Station Buildings

In architectural terms, Lostwithiel's main up side buildings conformed to a more or less standard Cornwall Railway plan, featuring a recessed central portion which formed a small *loggia* for waiting travellers. The building sported a low-pitched roof with tall chimneys and a projecting platform canopy, the general effect being vaguely Italianate. Similar buildings could be found at Saltash, St Germans, Penryn and elsewhere (though most Cornwall Railway stations were stuccoed rather than timber buildings). The down side buildings incorporated extensive canopies to provide shelter for passengers waiting on either the main line of the branch platform. The original up side building was dismantled in 1982 and transported section-by-section to the Plym Valley Railway for possible further use. A new station, incorporating a booking office, waiting room, toilet and staff facilities was erected in its place, and was formally opened in a ceremony held on 19 November 1982.

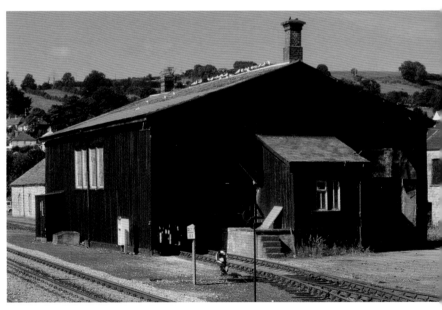

Right: Lostwithiel – The Goods Shed

Lostwithiel's main goods facilities were concentrated to the south of the passenger station on the up side. The usual goods shed, coal wharves, cattle pens and loading docks were provided, together with a 1 ton 10 cwt hand crane. Nearby, on a site contiguous to the goods yard, a range of traditional stone industrial buildings had formerly served as the Cornwall Railway's main locomotive and carriage works. The goods shed was another standard Great Western design, with large, arched entrances in its end gables for road and rail vehicles and a central transhipment platform. The building was of timber construction, with a low-pitched, slated roof and projecting office accommodation. Lostwithiel handled 10,182 tons of goods in 1913, rising to 11,109 tons in 1929 and 18,084 tons in 1930. Thereafter, the amount of goods tonnage handled each year decreased slightly, though the station was still dealing with 9,447 tons of coal, minerals and general merchandise traffic in 1938.

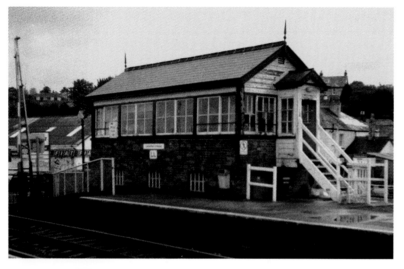

Lostwithiel – The Signal Cabin & Level Crossing

Left: The signal cabin was a brick and timber structure with small-paned windows and a gable roof. It was sited at the east north end of the down platform, from which position the signalman could obtain a good view across the adjacent level crossing.

Below left: A general view of the station, looking west towards Penzance during the 1960s. Like many country stations, Lostwithiel featured some well tended gardens, and in summer time its platforms were enlivened by colourful floral displays. The gardens incorporated several palm trees which, in later years, grew to a remarkable height in Cornwall's (generally) frost-free climate. The station was equipped with water columns on each platform, and these were fed from a stilted tank behind the Fowey branch bay.

Below right: The adjacent level crossing is now equipped with automatic lifting barriers, but the Great Western signal box remains in use on the down side.

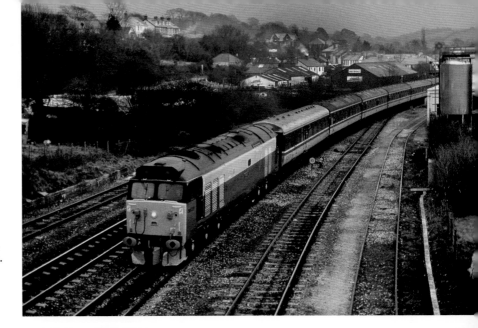

Above: Lostwithiel

Class '50' locomotive No. 50015 *Valiant* rounds the curve past
Lostwithiel creamery with the 11.19 a.m. Pathfinder Tours Penzance to
Bristol Temple Meads 'Cornish Centurion' rail tour on 26 January 1991.
Sister engine No. 50008 *Thunderer* is out of sight at the rear of the train.
The creamery was closed in 1991, although it was clearly still in use
when the photograph was taken, as a milk tanker lorry could be seen
parked beside the storage tanks.

Below: Lostwithiel

Class '50' locomotive No. 50031 *Hood* passes the old creamery at
Lostwithiel, as it works the 3.35 p.m. Penzance to Paddington 'Cornubian'
rail tour on 18 July 1998. In terms of passenger traffic, Lostwithiel was a
relatively busy station. In 1913, for example, it issued 40,151 tickets, while
in 1929 there were 46,134 bookings, together with 122 season ticket sales.
These healthy traffic statistics remained constant for many years and, in
1936, the station was still dealing with 39,608 bookings per year, while the
number of season tickets issued had risen to 390.

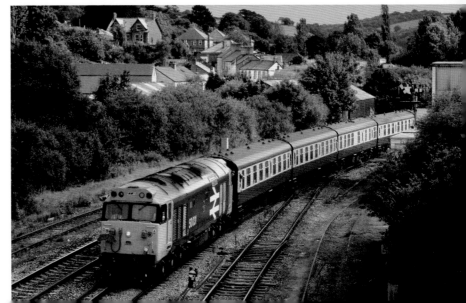

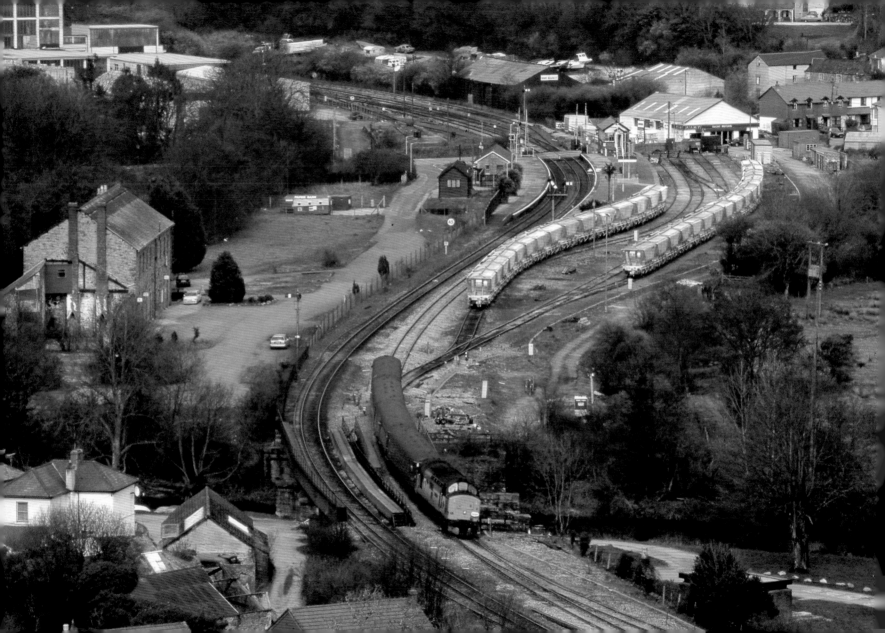

Par – The Cornwall Minerals Railway

On departing from Lostwithiel, trains head southwards with the Fowey branch running roughly parallel to the left, but, after about 1 mile, the main line curves to the right as it heads towards the 565-yard Treverrin Tunnel. Emerging into daylight, the railway drops towards the next stopping place at Par (280 miles, 53 chains) on gradients as steep as 1 in 63. Opened by the Cornwall Railway on 4 May 1859, Par station has lengthy up and down platforms, with an additional outer face for Newquay branch trains on the up side. The main station building is on the down side, and a minor road is carried across the line on an arched bridge at the north end of the platforms. The station is still a hive of activity, with goods sidings extant beside the branch on the up side.

The Newquay line originated in the 1840s when a local entrepreneur, Squire J. T. Treffry of Fowey, opened a mineral tramway from Ponts Mill, near Par, to Molinis near Bugle. In 1849, Treffry opened a second tramway from Newquay Harbour to clay workings near St Dennis, but these two lines were not linked until 1874, when the newly created Cornwall Minerals Railway inaugurated a freight service between Newquay and Fowey. Passengers were carried from 20 June 1876 and, in the following year, the GWR started to work the CMR line in return for 53 per cent of the gross traffic receipts. Finally, in 1896, the Cornwall Minerals Railway was sold to its much bigger neighbour, and the Par to Newquay line passed into full Great Western ownership.

In 1879, a standard gauge loop was installed between the main line station at Par and the CMR at St Blazey in order to provide a link between the Cornwall Minerals system and the GWR. These two postcard views provide a glimpse of Par station during the early years of the twentieth century.

Opposite: Lostwithiel

A panoramic view of Lostwithiel station, photographed from a hillside to the south-west of the town on 30 March 1996. Class '37' locomotive No. 37412 *Driver John Elliot* has just passed through the station, with the Pathfinder Tours 8.15 a.m. Cardiff Central to Newquay 'Cornish Raider' rail tour, on 30 March 1996. This high vantage point clearly shows the still extensive track layout at this busy Cornish location, many of its sidings and connections having remained in place in connection with China Clay traffic to Fowey. The freight-only line to Fowey can be seen diverging to the right, while the two-storey building that can be seen on the left was the former Cornwall Railway workshops.

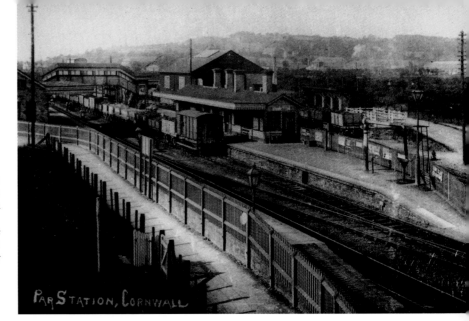

PAR STATION, CORNWALL

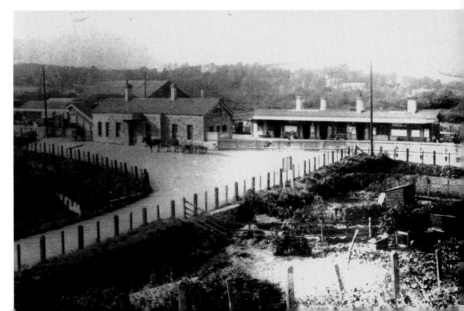

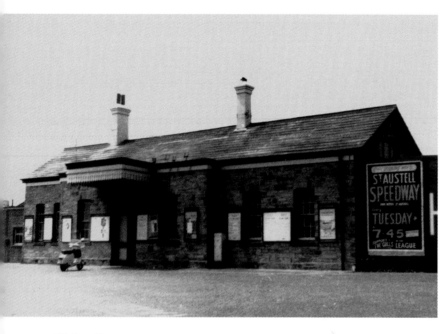

Right: Par

An HST set headed by power car No. 43182 speeds through Par station with the 3.50 p.m. Penzance to Paddington service on 22 June 1996. Plenty of period railway details have survived, including semaphore signals. The tracks that can be seen on the right-hand side of the picture are used extensively by China Clay trains, as well as the local passenger services to and from Newquay.

Left: **Par – The Main Station Building**

A detailed view showing the rear elevation of the main station building on 7 July 1963. This single-storey structure is constructed of local granite, with a gable roof and a full-length platform canopy.

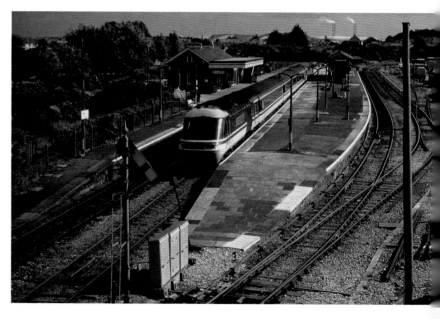

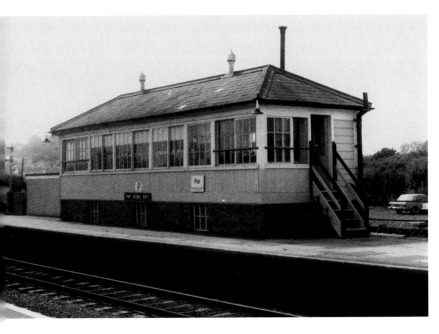

Right: **Par – The Up Platform**
A general view of the up platform during the 1950s, looking east towards Paddington with the goods shed to the left of the picture and the plate girder footbridge in the distance. Par was a relatively busy station during the Edwardian period, 47,591 tickets being issued in 1903, rising to 57,198 in 1913 and 65,226 by 1923. The number of ordinary bookings dropped slightly to around 51,000 per annum during the early 1930s, although the number of season tickets issued rose steadily from around 400 per year during the 1920s, to around 750 per year by the later 1930s. The station handled about 90,000 tons of goods traffic during the early 1900s, roughly 75 per cent of this traffic being in the form of mineral traffic. There was, thereafter, a decline in the amount of goods tonnage dealt with and, by the mid 1930s, Par was handling around 58,000 tons of freight per annum, the figures for 1937 and 1938 being 56,072 tons and 52,275 tons respectively.

Left: **Par – The Signal Box**
The signal box sited on the up platform is an interesting specimen that appears to have been reconstructed at some time in its career – the vertical match-boarding being a feature of many GWR signal cabins erected during the 1870s and 1880s, whereas the hipped roof is typical of the post-1896 period. When opened in 1879, the box had been equipped with a 26-lever frame, but this was increased to 57 levers by 1913, necessitating a considerable enlargement of the original box.

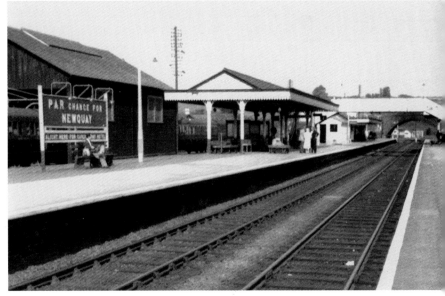

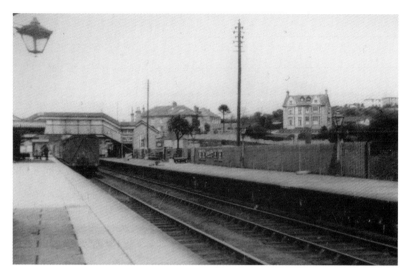

Par

Left: A view of the up platform looking east towards Paddington during the early years of the twentieth century.

Below left: A closer look at the platform shelter on the up side.

Below right: On leaving Par, the railway runs due southwards and, having reached the coast, trains then skirt Carlyon Bay Golf Links as they head west towards the next station at St Austell. The colour photograph shows class '50' locomotives Nos 50007 *Sir Edward Elgar* and 50033 *Glorious* running alongside the golf course at Carlyon Bay, with the 1.30 p.m. Plymouth to Penzance BR InterCity 'Royal Duchy' rail tour, on 26 September 1993.

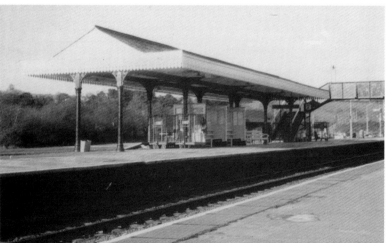

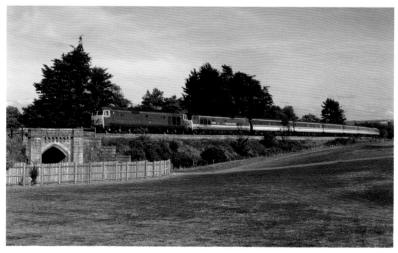

St Austell

Opened by the Cornwall Railway on 4 May 1859, St Austell (285 miles, 14 chains) is a two platform station with its main station building on the down side and a subsidiary building on the up platform. The main station building on the down side was demolished in 1999 and a modern building was erected in its place, although the up side building remains intact at the time of writing, this gable-roofed structure being of timber-framed construction. The up and down platforms are liked by a plate girder footbridge, and the station was formerly signalled from a standard GWR hip-roofed signal cabin that was sited to the west of the platforms on the up side (the box was closed in March 1980).

Prior to rationalisation, goods facilities had been sited on both sides of the running lines; a large goods shed was available on the down side, while the cattle loading dock was situated on the opposite side. In addition, St Austell was the starting point for the Trenance Valley branch, which ran from Trenance Junction to Lansalon; this goods only line was opened in 1920 and closed beyond Lower Ruddel in August 1964, the final closure being in May 1968.

The upper picture is looking west towards Penzance around 1912, the goods shed being visible to the left of the picture. The lower view was taken from a similar vantage point, probably during the 1920s.

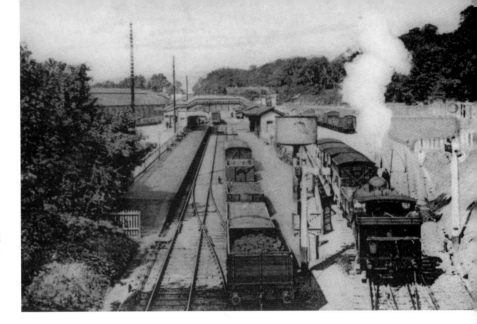

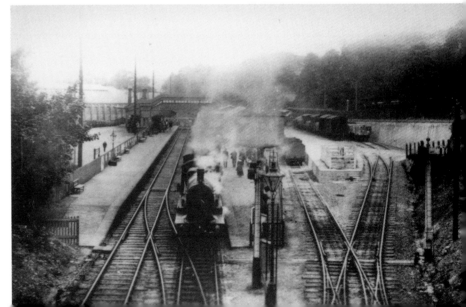

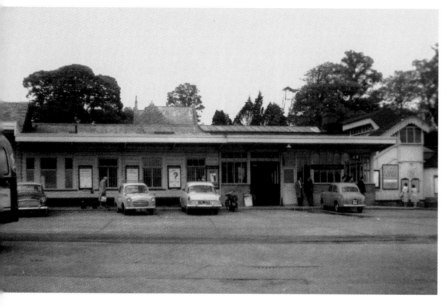

Right: St Austell

Work stained class '50' locomotive No. 50007 *Hercules* passes through St Austell station with a lengthy van train on 20 July 1978. Note the presence of various coaches, vans and wagons, and the resident class '08' diesel shunter, which was used to shunt Motorail stock. The footbridge and the down side station building still survive, but virtually everything else in this picture is now history, apart from *Hercules*, which, after running for many years as a green locomotive named *Sir Edward Elgar*, is now back on the main line in its original blue livery.

Left: St Austell – The Main Station Building

A detailed view showing the main, down side station building prior to its demolition. In traffic terms, St Austell has always been an important station; 65,097 tickets were sold in 1903, while 80,419 ordinary tickets and 168 seasons were issued in 1923. In 1903, the station handled 72,417 tons of goods, rising to 117,619 tons in 1913, 137,296 tons in 1923 and 135,071 tons in 1929. There was, thereafter, a gradual decline and, by the 1930s, the station was dealing with an average of about 80,000 tons per annum.

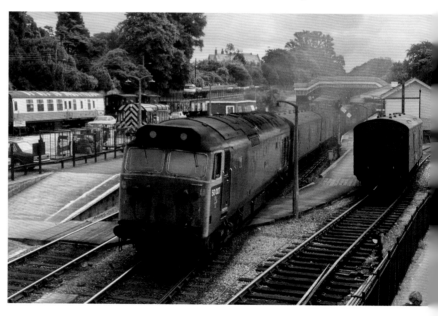

St Austell

Right: A further view of St Austell station during the early 1960s, looking east towards Penzance. The old coaches parked on the siding to the left of the picture were former camping coaches that had been handed over to the Signalling & Telegraph Department.

Below right: Western National buses parked on railway land on the up side of the station. The Western National Omnibus Co. was formed in 1929 as an amalgam of the National Omnibus & Transport Co. and the GWR. A controlling interest was acquired by the Tilling Group in 1931, but Western National nevertheless remained a 'railway associated' bus company.

Below left: A view of the station looking west towards Penzance during the early 1960s.

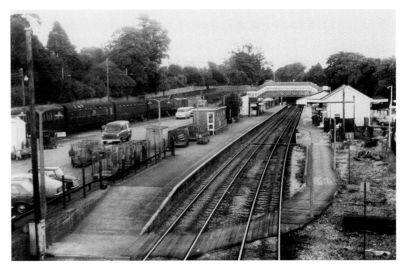

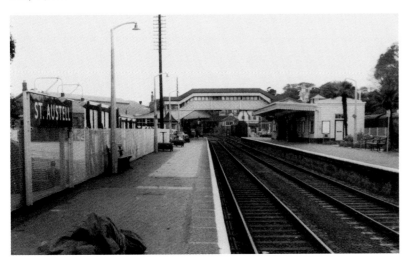

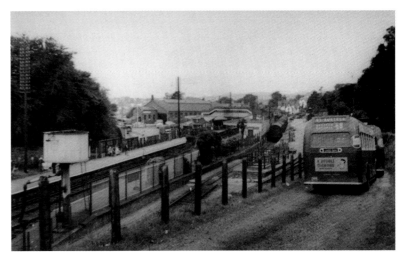

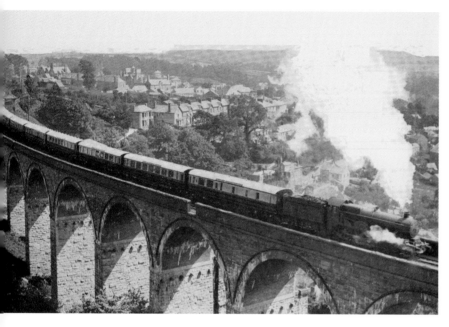

Right: St Austell – Gover Viaduct

The up Cornish Riviera speeds across Gover Viaduct (286 miles, 24 chains) around 1935. Situated less than three quarters of a mile beyond St Austell Viaduct, the eight-span Gover Viaduct was built in 1898 to replace an earlier Brunelian 'fan viaduct' – the gaunt stone piers of the original viaduct being left in situ on the north side of the present viaduct. Gover Viaduct is constructed of granite, with brick arches and parapets.

Left: St Austell – The Viaduct

Having left St Austell station, trains soon reach St Austell Viaduct (285 miles, 47 chains), some 206 yards in length, which carries the line across the Trenance Valley, and was rebuilt in 1898 with ten masonry arches. The viaduct is built on a slight curve, and the stone piers of the original Brunelian viaduct can be seen alongside. The photograph, taken on 8 July 1935, shows the Cornish Riviera Ltd passing over the viaduct, the train being composed of the Great Western's luxurious new 'Centenery Stock' – this being the inaugural run of the new rolling stock. GWR publicity claimed that the train ran 'non-stop to Truro' (St Erth on Saturdays), although, in reality it stopped at Devonport to change locomotives, the 'King' class 4-6-os being prohibited from crossing the Royal Albert Bridge.

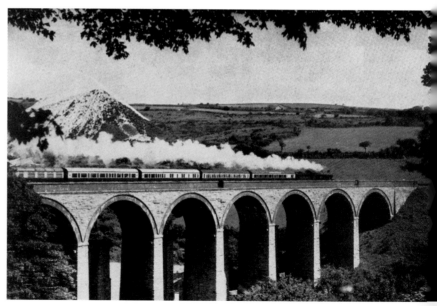

Burngullow

Left: Burngullow station (287 miles, 43 chains) was opened on 1 February 1863 and re-sited on 1 February 1896; the new site was 11 chains west of the original stopping place. In the event, the rebuilt station had a relatively short life, and all services were withdrawn in September 1931. The photograph, taken long after closure, is looking east towards Paddington, the former up station building being visible to the left, while the signal cabin can be seen to the right of the picture.

Right: A detailed view of the signal cabin, which was built of local stone.

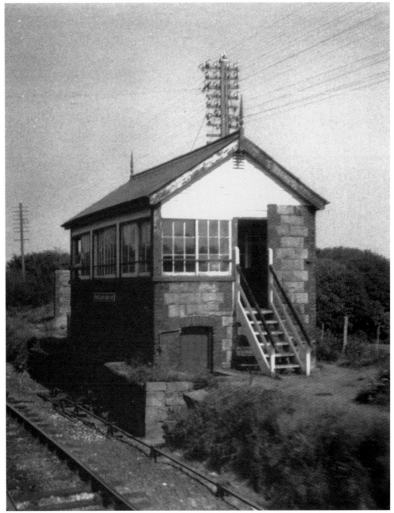

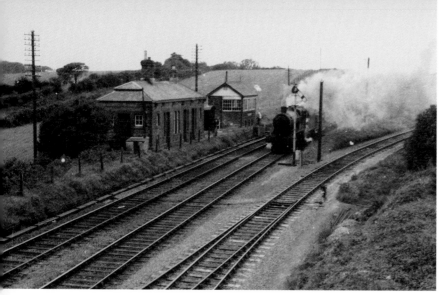

Above: Burngullow – The Newquay & Cornwall Junction Railway
Burngullow was the junction for the Newquay & Cornwall Junction
Railway, which diverged north-westwards at the east end of the station.
Opened on July 1869, the Newquay & Cornwall Junction line had originally
terminated at Drinnick Mill, but the line was later extended northwards to
provide a through route for mineral trains to and from St Dennis Junction,
on the Newquay branch. The branch was closed beyond Parkanddillack in
May 1966. The photograph, taken in the early 1960s, shows an up passenger
train passing through the former station, the Newquay & Cornwall Junction
branch being prominent to the right of the picture. In 1869, an engine shed
was opened alongside the branch, but this facility had closed by 1906 and
the building finally demolished in 1929.

Below: Burngullow – The Cornish Centurion Railtour
Class '50' locomotive No. 50008 *Thunderer* leaves the Newquay & Cornwall
Junction branch at Burngullow Junction, with the Pathfinder Tours 'Cornish
Centurion' rail tour, on 26 January 1991. The locomotive had been freshly
painted in an unusual variation of the BR 'rail blue' livery (later to be dubbed
'Laira Blue'), especially for this tour. This section of the Cornish main line
was singled in October 1986, but double track was subsequently reinstated
between Burngullow and Helland, to the east of Probus & Ladock platform.

Opposite: Burngullow
Class '47' locomotive No. 47497 passes Burngullow on 1 June 1979 with
an unidentified up working. This location has gone from double track to
single track, and back to double track since this picture was taken. On the
right is the Newquay & Cornwall Junction branch to Drinnick Mill and
Parkandillack, which is still used by China Clay trains.

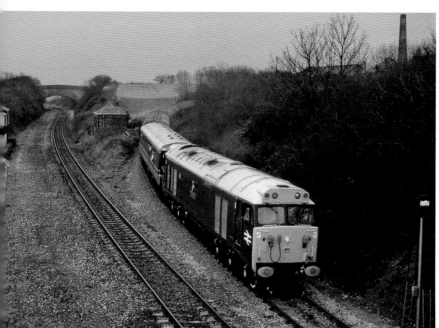

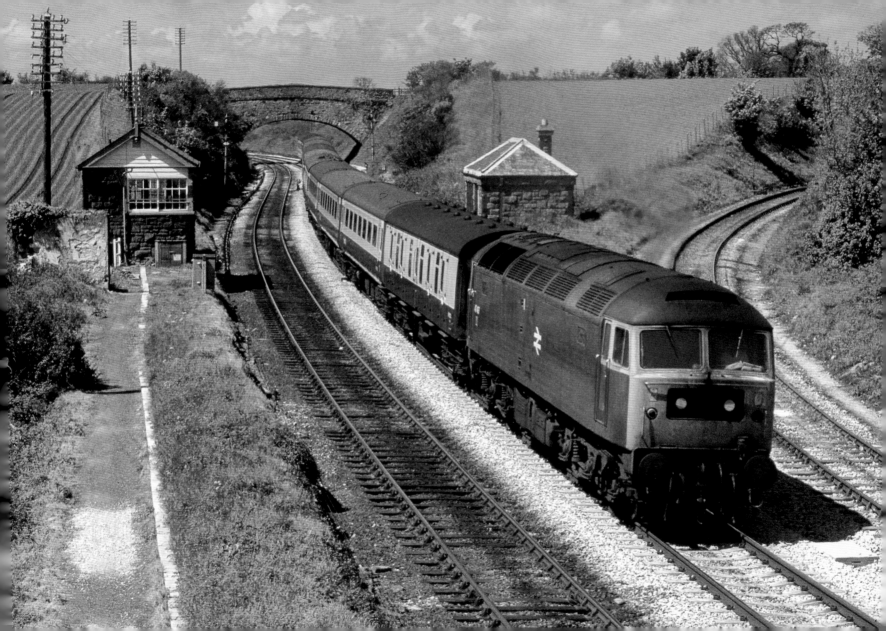

THE RAILWAY STATION GRAMPOUND RD

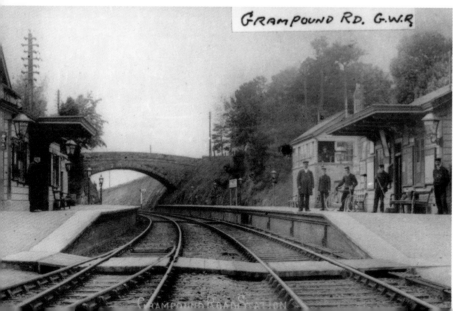

GRAMPOUND RD. G.W.R

Grampound Road

Heading south-westwards on falling gradients of 1 in 70 and 1 in 82, trains cross the Coombe St Stephen Viaduct (290 miles, 3 chains), and the River Fal Viaduct, after which the line climbs towards the site of Grampound Road station on a rising gradient of 1 in 97. This station, 292 miles, 4 chains from Paddington, was opened by the Cornwall Railway on 4 May 1859 and closed with effect from Monday 5 October 1964. The upper photograph, taken around 1912, is looking east towards Paddington with the up platform to the left, while the lower view, which also dates from around 1912, is looking westwards in the opposite direction. The wooden station buildings were single-storey structures with low-pitched gable roofs, which, from their Brunelian appearance, clearly dated from the Cornwall Railway era. The goods shed was, similarly, a typical Brunel-style building, whereas the standard gable-roofed signal cabin was a Great Western addition from around 1890.

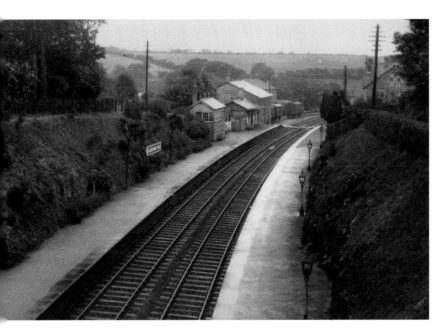

Right: Grampound Road

This final view of Grampound Road station is looking east towards Paddington during the early 1960s. The large and somewhat grim looking Victorian building at the rear of the down platform was built during the 1870s, and had no connection to the railway.

Left: Grampound Road

A general view of Grampound Road station, looking eastwards from the road overbridge. In 1903, this wayside station booked 16,224 tickets, rising to 17,708 tickets in 1913. The number of tickets sold in 1931 was 8,248 – an obvious decline in relation to earlier years, although at least part of this decrease can be attributed to the sale of season tickets. There were thirty-nine seasons sold in that year, whereas, in 1933, the number of season tickets sold had increased to seventy-one. In terms of freight traffic, Grampound Road handled around 16,000 tons of freight per annum during the early 1900s, falling to an average of approximately 6,000 tons per year during the 1930s. In 1937 and 1938, for example, the station dealt with 6,604 tons and 5,745 tons respectively.

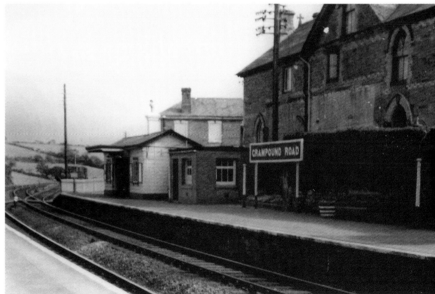

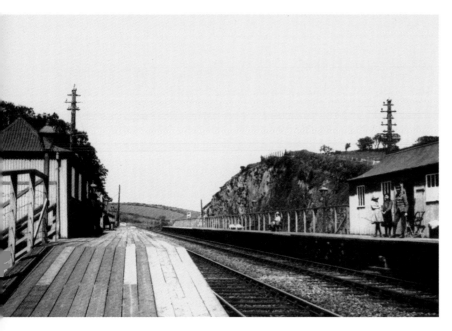

Right: Probus & Ladock Platform

In terms of traffic, Probus & Ladock Platform was one of the least important stopping places on the West of England main line. In 1913 it issued 9,063 tickets, but there was, thereafter, a steady decline and, by the mid-1930s, the station was booking around 1,000 ordinary tickets and a dozen or so season tickets per annum. By 1936, ticket sales were merely 767 (plus 11 seasons), the station's total receipts being only £358, whereas paybill expenses were £408. Perhaps surprisingly, this little used stopping place remained in operation until the British Railways period, before finally succumbing to inevitable closure in December 1957. Continuing south-westwards, trains cross the Tregarne and Tregeagle viaducts before passing through the 581-yard Polperro Tunnel and the 320-yard Buckshead Tunnel. The route then drops towards Truro on falling gradients of 1 in 78 and 1 in 87.

Left: Probus & Ladock Platform

From Grampound Road, the route continues south-westwards to the site of Probus & Ladock Platform (294 miles, 34 chains). This small station was opened on 1 February 1908 to serve the villages of Probus, about ¼ mile to the east of the railway, and Ladock, some 2 miles to the north. The platforms were of wooden construction, and the station buildings were enlarged versions of the usual Great Western 'pagoda' sheds. Probus & Ladock had a staff of three, while, for administrative purposes, this small station was under the control of the stationmaster at neighbouring Grampound Road. Although there were no goods facilities, the station dealt with around 1,500 parcels and other small consignments each year. According to a 1938 GWR staff publication entitled *Towns, Villages & Outlying Works, Etc.*, collection and delivery work in the surrounding area was carried out by a private carrier.

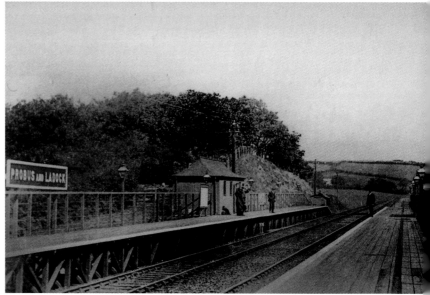

Truro – Some Historical Notes

Situated a little under 300 miles from Paddington (via Bristol), Truro is a relatively large station. The approach from the east is spectacular, in that westbound services pass over the majestic Truro and Cavedras viaducts, which provide excellent views of Truro Cathedral and the distant Truro River, as trains slow for their final approach to this busy Cornish station. Cavedras Viaduct was rebuilt in 1903, while Truro Viaduct was reconstructed in the following year.

When opened on 4 May 1859 as the western terminus of the Cornwall Railway, Truro had featured a range of stone buildings on the down side. There were three through platforms and a shorter bay, with a 'third line' between the main up and down platform lines, and two mixed gauge loop lines to the north. The goods yard was sited on the down side, and a wooden engine was situated on the up side of the station. The original layout was modified and enlarged throughout the nineteenth century, while the engine shed was moved to a new site at the west end of the station between Penwithers Tunnel and an area known as 'Dobb's Field'.

The station was extensively reconstructed at the end of the Victorian period and, by the early the twentieth century, the layout incorporated three through platforms and an additional bay on the down side for Falmouth branch trains. The platforms were numbered in sequence from 1 to 4, platform 1 being the Falmouth branch bay, while platform 2 was used by down main line services between London and Penzance. Platform 3 was used by Newquay and Perranporth branch workings, while platform 4, on the far side of the station, was served by up main line trains to Plymouth, Exeter and beyond. The upper photograph shows Truro station from the north-west during the early 1900s, with platform 4 visible beyond the stationary passenger vehicle. The lower view, dating from the 1930s, shows an unidentified '45XX' class 2-6-2T on platform 3, with what appears to be the Falmouth portion of the Cornish Riviera Express.

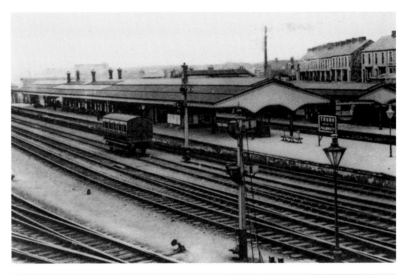

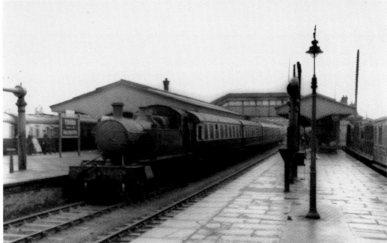

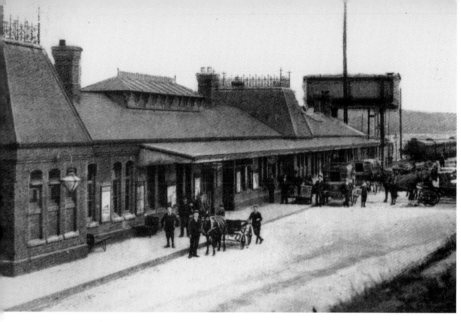

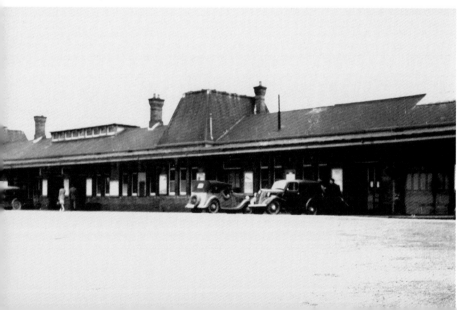

Truro – The Station Buildings

The station is lavishly equipped with a range of red-brick station buildings. In architectural terms, Truro is a typical late Victorian GWR station, the main building, on the down side, being a single-storey structure with a hipped slated roof. Two of its bays are graced by French-style towers, and there is, in addition, a raised glass clerestorey or cupola over part of the building. The roofline was, at one time, punctuated by an array of tall brick chimney stacks, but most of these have now been removed.

Additional buildings are available on the up side, and these also date from the great rebuilding that was carried out by the GWR at the end of the Victorian period. Facilities on the up side include waiting rooms, staff accommodation and toilets. The construction of these buildings was authorised on 18 November 1896 at an estimated cost of £5,500, although an extra expenditure sum of £1,872 8s 1d was incurred before the new station facilities were completed in 1900. The platform coverings were extended in 1936 with the aid of cheap government loans. The Victorian station buildings survive intact, albeit with modified internal arrangements, in that the ticket office and travel centre now occupy the eastern end of the main down side building. The upper picture shows the main station building around 1912, while the lower shows this standard GWR structure during the 1930s.

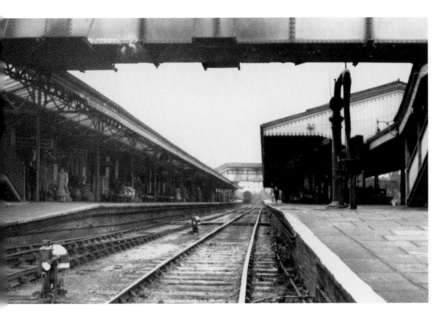

Right: Truro – The Falmouth Branch Platform

A Falmouth branch train waits for its connection in platform 1. The locomotive in this *c.* 1950s view is '45XX' class 2-6-2T No.5557. In its present-day form, Truro has three platforms, the former platforms 2 and 3 being used by main line traffic while platform 1, on the down side of the station, continues to serve as the Falmouth branch bay. Platform 4, the outer platform on the up side, has been removed, and platform 3 now serves as the up main platform.

Left: Truro – The Main Platforms

The platforms are linked by two standard GWR plate girder footbridges, one of which is sited at the east end of the station, while the other is situated near the centre point of the main platforms. In addition, a pedestrian footbridge spans the western end of the platforms, and this sinuous structure provides an excellent vantage point for youthful 'spotters'. In 1912, platform 2 was lengthened from 484 feet to 634 feet, and platform 3 was lengthened from 450 feet to 600 feet at a cost of £398. Further extensions increased platform 2 to 650 feet, while platforms 3 and 4 were extended to 685 feet; the latter platforms formed the two sides of an island, whereas platform 2 was a side platform with the Falmouth bay at its western end. Water columns were available at the west end of platforms 2 and 3, and at the east end of platform 3. These were fed from a water tower to the east of platform 2.

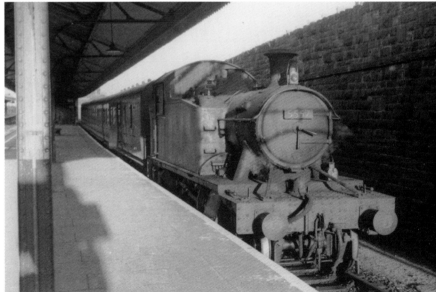

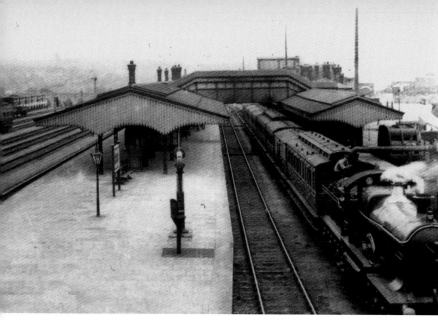

Truro – 4-4-0 Locomotives

Above: An unidentified 'Bulldog' class 4-4-0 takes water in platform 2 during the early 1900s. At the end of the Victorian period, the Cornish main line was worked mainly by 4-4-0 and 0-6-0 locomotives - 4-4-0s such as the 'Duke' and 'Bulldog' classes being employed on passenger work, whereas the 0-6-0s appeared on goods workings. The 60-strong 'Duke' class 4-4-0s were introduced in 1895 especially for South Devon and Cornwall express work, while the 'Bulldog' class engines were in effect improved 'Dukes', being double-framed engines with 5 ft 8 inch coupled wheels.

Below: A busy scene at Falmouth station during the early years of the twentieth century. 'Bulldog' class 4-4-0 No. 3432 *River Yealm* stands in platform 2 with a down express, while a rebuilt '3521' class 4-4-0 waits in platform 3 with a local stopping train. A Falmouth branch train occupies platform 1, to the right, while platform 4, on the extreme left of the picture, appears to be occupied by an up milk and parcels train. The slatted 'siphon' beyond the gas lamp is a milk-carrying vehicle.

Opposite: Truro

A general view of the station, looking west towards Penzance around 1962. The trailing connection that can be seen in the foreground gave access to the now-closed goods yard, which contained a number of dead-end sidings, together with a large goods shed, a loading bank and a cattle loading dock.

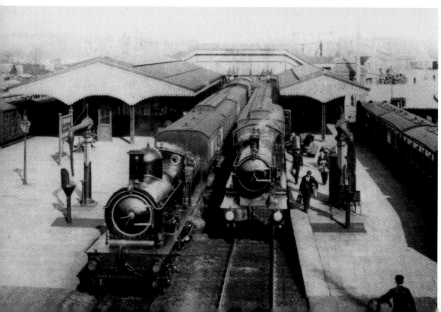

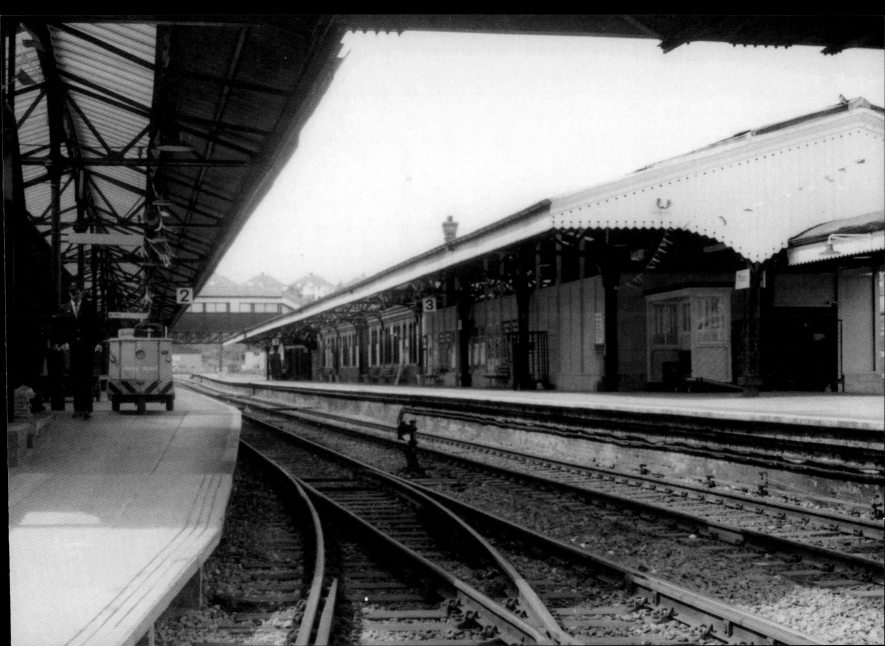

Right: Truro

A general view of the station, looking east towards Paddington during the 1960s. At that time, Platform 4 was flanked by an array of parallel loops and sidings, two of which functioned as up and down goods loops. The loops were linked to a series of crossovers and connections, by means of which trains were able to enter Truro engine shed and an array of parallel sidings on the north side of the station. These extended eastwards, and they were used mainly for storage and marshalling purposes, while six further sidings extended westwards to provide additional stabling facilities for passenger vehicles. Truro's goods traffic amounted to around 23,000 tons a year during the 1930s, though there was a dramatic rise during the Second World War, which was sustained during the BR era. In 1941 and 1942, the station handled 35,572 and 32,272 tons of freight respectively, rising to an average of 80,000 tons per annum during the period 1947–52.

Left: Truro – The East Signal Box

In steam days, Truro station was signalled from two standard Great Western brick-and-timber signal cabins, which were known as Truro East Box and Truro West Box. Both were typical '1896-type' hipped roof boxes with five-pane windows. The West Box was situated to the north of the goods loops at the west end of the station, while the still-extant East Box is sited to the east of the up platform. Most of the sidings on the north side of the line were eliminated during the mid-1990s and, in connection with this reduction in facilities, Truro West Signal Box was closed, with the control of the remaining signals and connections concentrated in the former East Box.

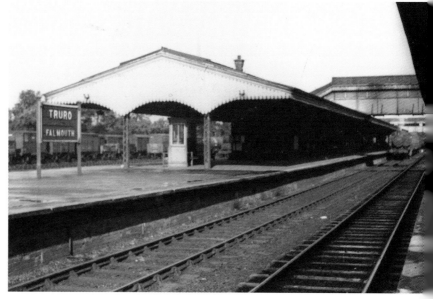

Truro

Right: Looking eastwards along platform 3, with the up sidings visible to the left. In 1972 a new bulk freight terminal was opened on the site of the former up side yard. Two long sidings were available for wagon load traffic, while a third siding served a nearby warehouse. Access to the freight terminal is by means of a level crossing, with full-length lifting barriers that are controlled from the adjacent Truro West Signal Box.

Below left: Class '50' locomotive No. 50031 *Hood* leaves platform 2 with an up passenger train on 21 September 1983.

Below right: A view of the down side station building during the 1980s.

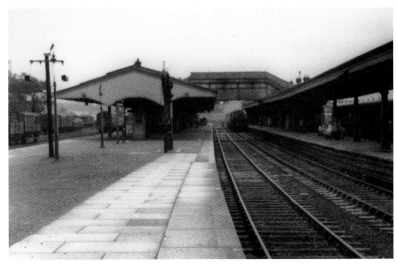

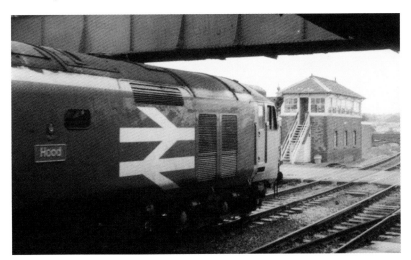

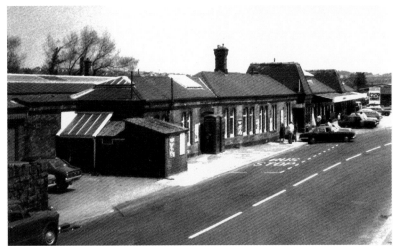

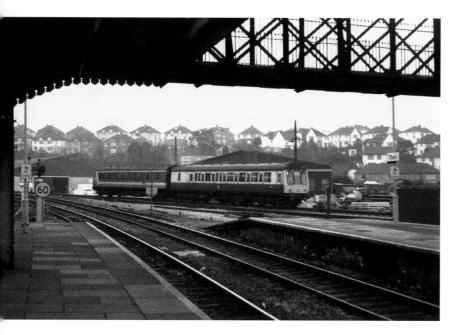

Left: Truro – 'First Generation' Multiple Units

In the 1990s, the Falmouth branch was worked by class '101', class '117' and other 'first generation' multiple units, a popular set being No. 117305, which was composed of motor second No. 51410, trailer composite No. 59520 and motor brake second No. 51368 – all three vehicles smartly turned out in traditional Great Western-style chocolate and cream livery. The last 'first generation' multiple units left Cornwall in March 1997 and, thereafter, the Falmouth route and other local branch lines were worked by class '150' and class '153' units. The photograph shows a class '117' set in hybrid livery at Truro, one of the vehicles being in Network South East livery, while the other sports GWR-style chocolate and cream livery. This unit was composed of motor brake seconds Nos 51368 and 51361.

Right: Truro – Tickets & Traffic

A selection of Edmondson card tickets from Truro, Redruth and other stations at the eastern end of the Cornish main line. In terms of passenger traffic, Truro was the busiest station in Cornwall, and around 130,000 tickets a year were issued during the period 1903–38. In 1913, for example, the station issued 149,577 tickets, while in 1930 150,529 tickets and 417 season tickets were issued. In the later 1930s, there was an apparent decline in bookings, though in reality this was due to the vastly increased use of season tickets. By 1938, ordinary bookings were down to 108,930, whereas season ticket sales had risen to 2,151 per annum. In 2012/13, the station generated over 1.5 million passenger journeys.

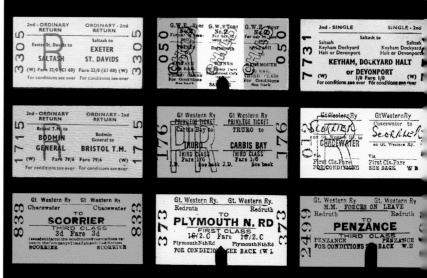

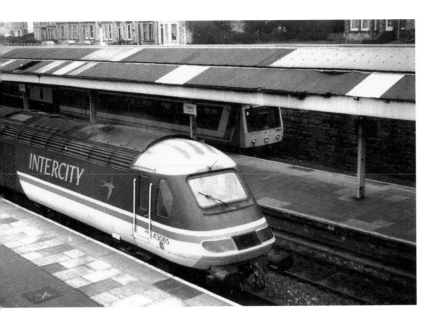

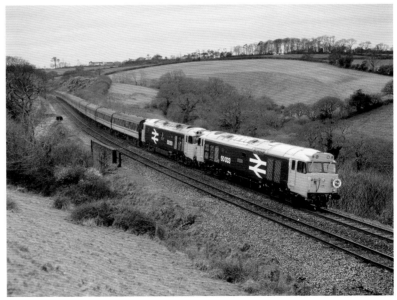

Left: **Truro – Diesel Power**

An eastbound HST set stands in platform 3 at Truro in March 1996, with power car No. 43065 at the rear. In 1987, No. 43065 and seven other power cars were fitted with buffers in order that they could work as 'DVT' trailers in conjunction with class '89' and class '91' locomotives on the East Coast Main Line. These distinctive, 'buffered' power cars later joined the Virgin Trains fleet for use on the Virgin CrossCountry and Virgin West Coast routes, and in this capacity they worked long distance services between Penzance and destinations as far north as Edinburgh and Aberdeen.

Right: **Truro – Class '50' Farewell**

In immaculate 'large logo' livery, class '50' locomotives Nos 50033 *Glorious* and 50050 *Fearless* sweep round the reverse curves near Buckshead Tunnel to the east of Truro, with the Pathfinder Tours 'Cornish Caper' rail tour, on 19 March 1994, just one week away from their final excursion on the rail national network. This mammoth tour had left York at 9.15 p.m. on the previous evening and travelled as far as Bristol Temple Meads behind two class '47' locomotives – Nos 50007 *Sir Edward Elgar* and 50050 *Fearless* – then took over for the run to Cornwall, where No. 50033 *Glorious* was added to 'top and tail' the train over the Newquay and St Ives branches, leaving the 'large logo' pair to work the tour back to its starting point at York.

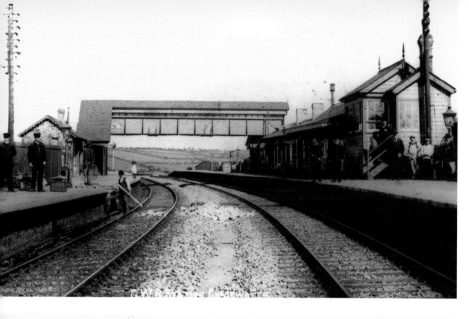

Chacewater

On leaving Truro, westbound trains pass through the 70-yard Penwithers (or Highertown) Tunnel, beyond which the Falmouth branch diverges from the West Cornwall main line at Penwithers Junction (300 miles, 12 chains). It is noticeable that Falmouth services enjoy a straight run onto the branch, whereas main line trains are faced with a sharp right-hand curve. This is an interesting legacy of the original Cornwall Railway, which had been planned as a main line link between Plymouth and Falmouth. Penwithers was also the junction for the now closed Newham branch, which carried passengers between 1855 and 1863, but was otherwise used purely for goods traffic.

From Penwithers Junction, the West Cornwall route continues westwards on a ruling gradient of 1 in 80, which extends for around 3 miles towards Chacewater. Trains soon reach the 124-yard long Penwithers Viaduct (300 miles, 70 chains), which was rebuilt as a masonry structure in 1887. Beyond, the railway continues its ascent, and then drops towards Chacewater (304 miles, 68 chains) on a series of falling grades. Nearing the station, trains cross two more viaducts, the first of which, known as Chacewater Viaduct, is 99 yards long and 52 feet high, while the second – the seven-arch Blackwater Viaduct – is 132 yards long and 68 feet high.

When opened on 1 November 1853, Chacewater had been merely a wayside station, but, on 6 July 1903, the Great Western opened a short branch from Blackwater East Junction to Perranporth, this new line being the first section of a through route to Newquay. The Chacewater to Newquay line was completed throughout on 2 January 1905, and Chacewater thereby became the junction for branch services to Perranporth and Newquay – although trains generally ran through to Truro.

The upper picture shows the station before the opening of the Newquay line, whereas the lower view dates from around 1910, by which time Chacewater had become a three platform layout – the up platform having been transformed into an island with an additional face for branch services. The main passenger facilities were concentrated on the down side – a range of simple wooden buildings being provided on this platform. Internally, they contained the usual booking office and waiting room accommodation. A typical GWR-style roofed footbridge gave access to the up platform, which was equipped with a waiting room and toilet block.

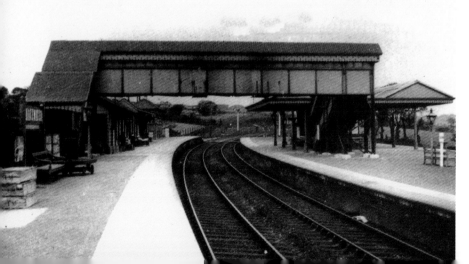

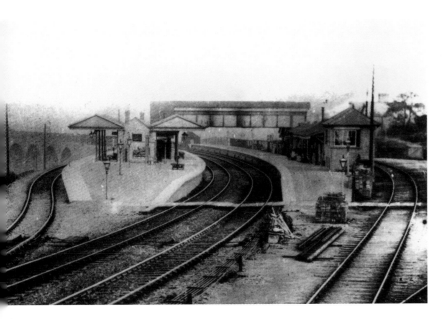

Left: Chacewater

Chacewater station, looking east towards Paddington during the Edwardian period. The down platform can be seen to the right, while the island platform, with its outer face for branch line traffic, is to the left of the picture. The track plan here was relatively simple: the third platform face was served by a loop line from the up main line, while goods facilities consisted of two short, dead-end sidings and a headshunt on the down side. The up and down main lines were linked by crossovers, and there was a short, dead-end spur at the eastern end of the loop line. The downside buildings were damaged by fire in 1947, but new buildings were provided in the 1950s. The station was originally signalled from a gable-roofed signal cabin on the down platform, but this box was subsequently replaced by a hip-roofed cabin, which was brought into use in 1914. Other facilities at Chacewater included a goods loading bank and 2-ton fixed yard crane.

Right: Chacewater

A busy scene at Chacewater during the early 1900s, with passenger trains in all three platforms. In the early 1920s, Chacewater had a staff of ten, including 2 leading porters, 2 porters, 1 class four stationmaster and 5 signalmen, who were needed in connection with the various signal boxes in the immediate vicinity. In 1924, the staffing establishment was reduced to seven and, following this alteration, the labour force at Chacewater comprised two leading porters, two porters, a class four station master, and just two signalmen, who undertook duties in the station box. Passenger bookings averaged around 15,000 per year during the period between 1930 and 1938, though freight traffic was less important and, in most years, the goods yard dealt with little more than 1,000 tons of coal and general merchandise traffic.

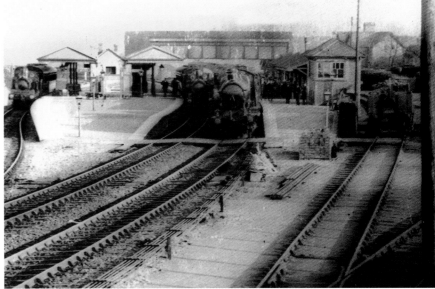

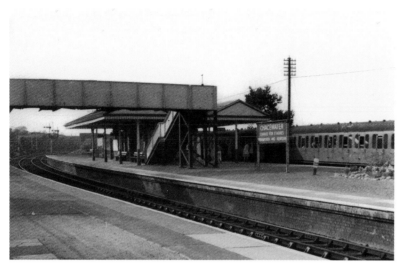

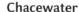

Chacewater

Left: A *c.* 1960 view of the station, with a Newquay train in the branch platform. Sadly, the Chacewater to Newquay line was closed with effect from Monday 4 February 1963. The last trains ran on Saturday 2 February, and the final services were formed of four-car multiple units. Numerous photographs were taken on the last day, and there was a scramble to buy the last tickets – many of which were still of GWR origin.

Below left: The western end of the station around 1963.

Below right: Class '50' locomotives Nos 50001 *Dreadnought* and 50032 *Courageous* pass through the remains of Chacewater station with an up passenger working on 27 April 1979. A class '45' locomotive is just visible in the siding on the background. Although the station was closed to passengers with effect from 5 October 1964, the Blue Circle cement works that had been set up in the station yard lingered on until the 1980s.

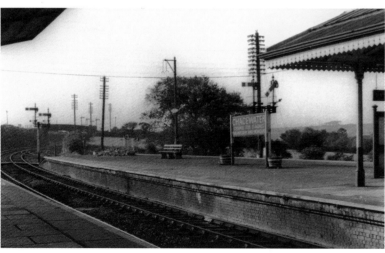

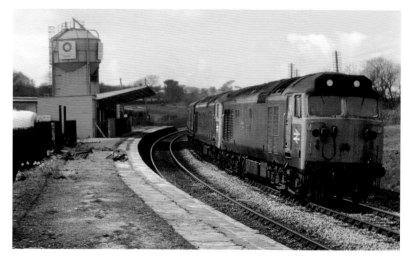

Scorrier

From Chacewater, the route runs westwards to Blackwater East Junction, a distance of 22 chains. At this point, the Newquay and Perranporth route had joined the main line by means of a triangular junction, but these arrangements were simplified in 1924 when the branch was extended eastwards into Chacewater station and the physical junction was abolished. Scorrier, just 2 miles further on, was opened as 'Scorrier Gate' on 25 August 1852. Scorrier was one of the smallest intermediate stations en route to Penzance, and its facilities consisted of two platforms for up and down traffic, each of which was 371 feet in length. The main station building was on the down platform and there was a small waiting room on the up side. In later years at least, the station had no cattle pens, end loading docks or yard crane, though the 1938 Railway Clearing House *Handbook of Stations* reveals that a private siding connection to the nearby Wheal Busy mine, about a quarter of a mile to the east, was still available for use.

The upper picture shows the main station building around 1912, together with the standard GWR hipped-roof signal cabin, which was sited immediately to the east of the down platform. The lower view, again from around 1912, is looking eastwards along the up platform.

Until 1930, Scorrier was of operational significance, in that it marked the end of the double track section from Truro, the short section westwards to Redruth being single line. However, in that year the GWR doubled the line between Scorrier and Redruth by a distance of just over 1½ miles, this work undertaken as part of an unemployment relief programme sanctioned by the government. Scorrier was listed for closure in the 1963 Beeching Plan. The closure was carried out as planned, with effect from Monday 5 October 1964, when Scorrier and four other Cornish stations were removed from the British Railways network.

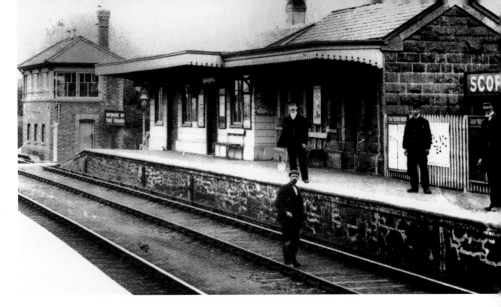

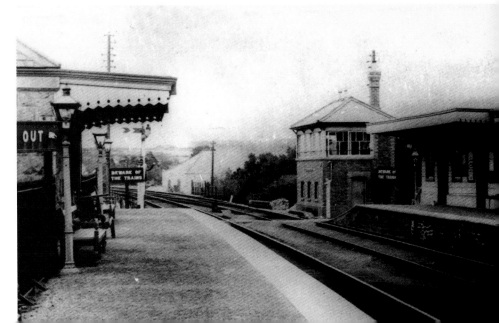

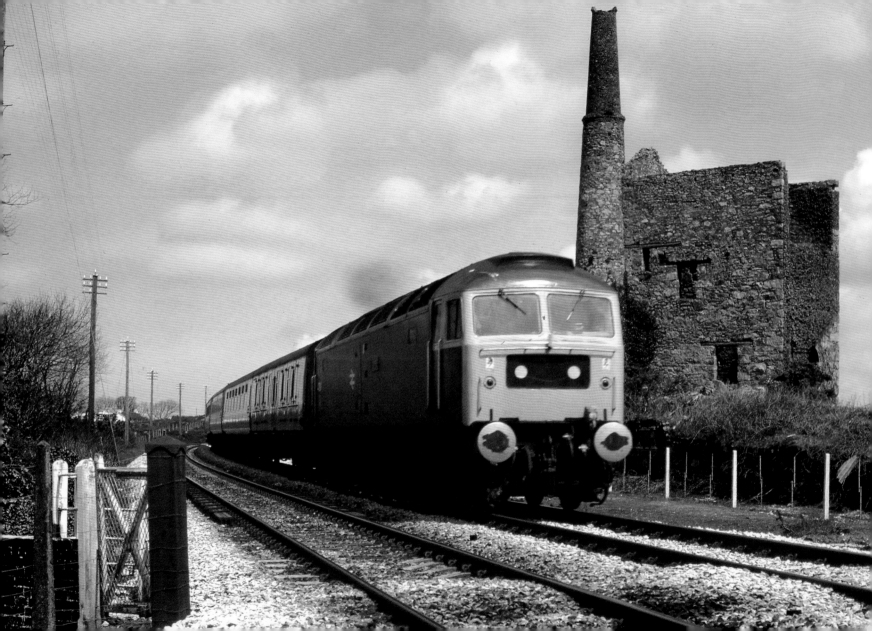

Scorrier – Class '50's at Hallenbeagle

Right: Class '50' locomotive No. 50041 *Bulwark* passes the remains of Reade's shaft engine house at Hallenbeagle mine, near Scorrier, with an unidentified working on 27 April 1979.

Below left: Class '50' locomotives No. 50050 *Fearless* and 50007 *Sir Edward Elgar* run alongside the A30 at Scorrier as they head towards Penzance with the 9.15 p.m. Pathfinder Tours York to Penzance 'Cornish Caper' rail tour on a very damp 19 March 1994. Sister locomotive No. 50033 *Glorious* can be seen on the rear.

Below right: A closer view of class '50' No. 50033 *Glorious*, partly veiled in its own exhaust as its assists at the rear of the 'Cornish Caper' rail tour, at Scorrier, on 19 March 1994.

Opposite: Scorrier

Class '47' locomotive No. 47511 *Thames* passes the closed Hallenbeagle mine with an unidentified southbound working at around midday on 27 April 1979. The silver buffers were presumably a reminder of its naming ceremony, which had taken place just over a month earlier.

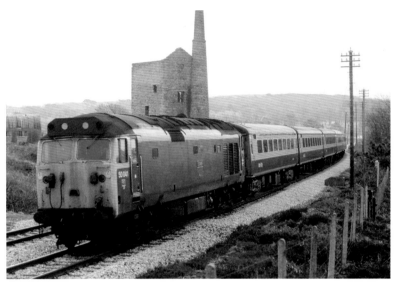

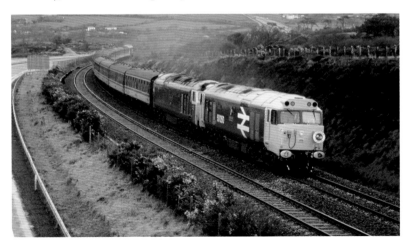

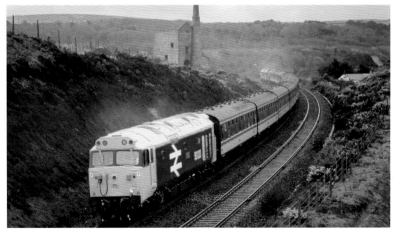

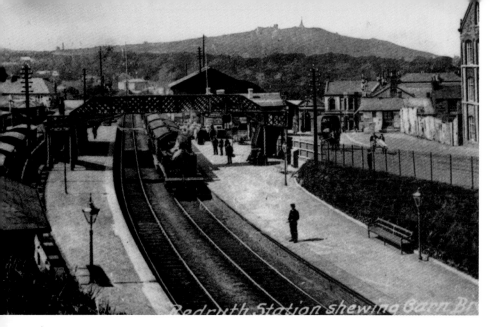

Redruth Station shewing Barn Br...

REDRUTH

Redruth

Running through a landscape punctuated by the characteristic stone-built engine houses of the Cornish tin mining industry, down trains soon reach Redruth (308 miles, 55 chains), the station being approached through the 47-yard Redruth Tunnel. Redruth was served by the Hayle Railway as early as 1838, although the present station was opened by the West Cornwall Railway on 11 March 1852.

The original WCR station was a passing place on what was then a single line, with simple wooden buildings on the up platform and a timber goods shed, both of these structures being of standard 'Brunelian' design. This first West Cornwall station survived for many years, but major changes were put into effect in 1912, when the Great Western opened a new goods yard at Drump Lane, some 33 chains to the east of the passenger station. Most goods handling facilities were transferred to the new goods depot, though a dead-end siding was retained on the up side of the passenger station, together with a short spur that terminated in a loading dock on the site of the former goods shed.

Further changes were initiated at Redruth in the 1930s, as a result of which the 1852 station building was demolished, and the present red-brick booking office and waiting room was erected on the up side. The down side building, in contrast, is a timber-framed structure clad in horizontal weather boarding, while the up and down platforms are linked by a lattice girder footbridge. The upper view, from an Edwardian postcard dating from around 1909, looks west towards Penzance, prior to the 1912 reconstruction scheme, and the original goods shed can be seen in the distance. The lower picture, dating from the end of the Victorian era, shows members of the local Rifle Volunteer Corps on the up platform – the 'Volunteers' were the predecessors of the present-day Territorial Army.

Left: Redruth

The main station building, photographed on 12 March 1996. In steam days, Redruth had boasted a full range of goods facilities. Drump Lane Goods Yard was equipped with loading docks, cattle pens, a commodious goods shed and a 6-ton yard crane. A private siding served the West of England Bacon Co.'s nearby premises (later purchased by Messrs C. & T. Harris of Calne). Until its closure in 1936, the Hayle Railway's Tresavean branch had provided a tangible link with the early days of railway operation in West Cornwall. The branch had diverged south-eastwards from the West Cornwall main line at Redruth Junction (9 miles, 45 chains), and this junction had also given access to the former Hayle Railway terminus, which remained in use for many years as a coal yard.

Right: Redruth

A detailed view of the down side station building on 12 March 1996. This timber-framed structure is considerably older than its counterpart on the up platform. Redruth was an important traffic centre for both passenger and freight traffic and, in the 1920s and early 1930s, its passenger bookings exceeded 100,000 tickets per year. In 1923, for instance, the station issued 127,547 tickets and 889 seasons, while, in 1935, 101,059 ordinary tickets and 1,015 seasons were issued. The amount of goods traffic handled over the same period declined from 45,009 tons in 1923 to 20,380 tons in 1935, though the annual figure had increased to 27,193 tons by 1938. The types of goods traffic handled during the 1930s were typically coal and general merchandise, the heyday of the Cornish mining industry having long passed by that time.

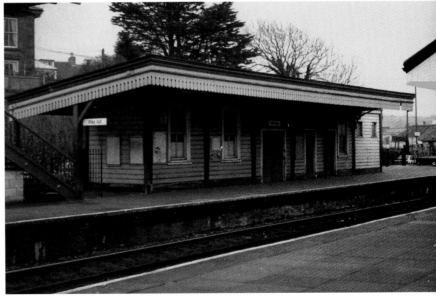

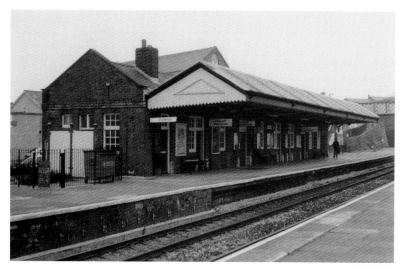

Redruth

Left: A further view of the main up side station building on 12 March 1996. Internally, the building contains the usual booking office and waiting room facilities, together with a small refreshment room.

Below left: Class '25' locomotive No. 25207 emerges from the short Redruth Tunnel and passes through the station, with a train of grampus wagons on 26 July 1978. This locomotive was transferred from Longsite depot in Manchester in March 1978, and it remained on the Western Region for two years.

Below right: An unidentified GWR 4-4-0 locomotive heads westwards over Redruth Viaduct (308 miles, 66 chains) during the early twentieth century. This viaduct, originally of timber, was rebuilt as an eight-arch masonry structure in 1882; the siding on the extreme left of the picture gave access to the WCR goods shed, which can be seen on page 92.

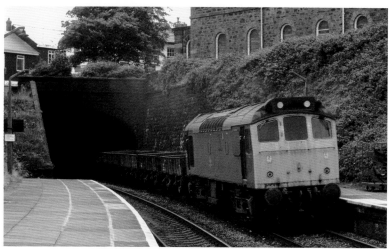

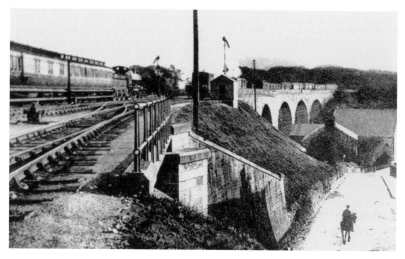

Carn Brea

Carn Brea, the next station (310 miles, 57 chains), was formerly the junction for goods services to Portreath, which ran northwards over the former Hayle Railway branch. The layout consisted of up and down platforms linked by a plate girder footbridge, with small buildings on each platform as shown in the photographs. There was a goods yard on the up side, together with up and down relief sidings, the down siding being parallel to the running line, while the up siding extended along the rear of the goods yard. The yard itself was equipped with loading banks and a 6-ton fixed hand crane, while Carn Brea Yard was just 19 chains to the east.

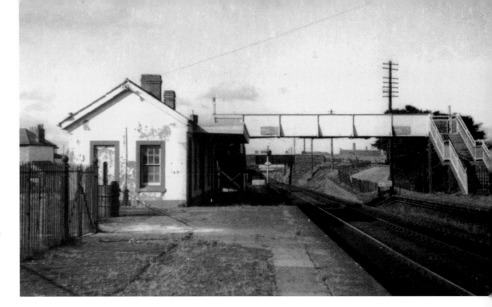

The infrastructure here was fairly complex, the station being the junction, not only for the Portreath branch, but also the North Crofty branch, which joined the main line just 31 chains to the west of the passenger station. Carn Brea Yard was situated on the up side of the running lines. It consisted of two loop lines from which sidings branched out to serve coal wharves and the former West Cornwall Railway locomotive sheds and workshops. The Portreath branch converged at the east end of the yard, the junction being affected by means of a single turnout.

The amount of traffic handled at Cam Brea decreased inexorably during the late nineteenth century and early twentieth century, particularly in terms of freight. In 1913, 56,211 tons of goods was handled, but this figure had dropped to around 5,000 tons per annum during the 1930s. On the passenger side, Carn Brea's bookings dropped from 38,213 tickets in 1913 to 5,425 ordinary tickets and 18 seasons in 1938. The Portreath branch was closed to all traffic beyond North Pool on 1 January 1936, and the remaining section was closed on 1 April 1938. Carn Brea station was closed with effect from 2 January 1961 and little now remains to mark the site of. The goods yard was taken out of use in 1965–67, while Carn Brea Yard was closed in August 1967.

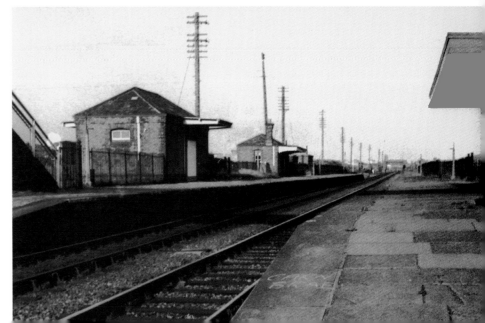

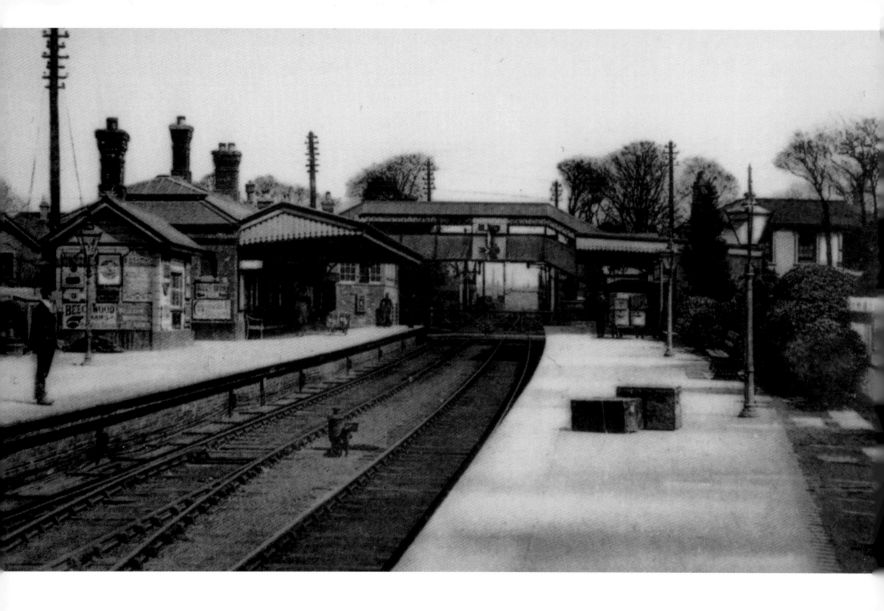

Camborne

From Carn Brea, the route continues for a little under 2 miles to Camborne, the view from the carriage windows being predominantly industrial as trains pass a succession of ruined engine houses and overgrown spoil heaps. There was, at one time, a stopping place at Dolcoath, but this small halt had a life of only three years, having opened in 1905 and closed in 1908. Dolcoath Siding (311 miles, 50 chains) remained in use for coal and later milk traffic, while at nearby North Crofty Junction, the North Crofty goods branch diverged northwards from the main line. Dolcoath siding was finally taken out of use in December 1983, while North Crofty goods siding was closed in 1948 and lifted in the following year.

Camborne (312 miles, 25 chains) is in many ways the 'capital' of the Cornish mining district. The station predated the West Cornwall Railway, having been opened by the Hayle Railway in 1837. Passenger services commenced in 1843, while the West Cornwall station was opened on 11 March 1852. Up and down platforms are provided, while Trevu Road crosses the line on the level at the east end of the station.

Prior to rationalisation, Camborne had been equipped with goods sidings on both sides, the main goods yard being on the down side, while two further sidings were situated behind the up platform. These sidings were linked to the main lines by a system of crossovers, one of which left the up running line by a trailing connection and crossed the down line on the level, in order to reach the goods shed and adjoining sidings. The goods shed was used for the loading and unloading of general merchandise traffic, while the nearby sidings were available for the handling of coal, minerals and other forms of bulk traffic. The yard crane was of 4 tons capacity in the 1920s, but was it was later increased to 6 tons. The up sidings were removed in the 1930s, and the goods yard sidings have now been lifted, but this has enabled the up and down platforms to be considerably lengthened and eight-car HST formations can now be accommodated with ample room to spare.

The upper view shows the up platform during the early 1960s, while the lower photograph was taken from the footbridge in March 1996.

Opposite: Camborne
A postcard view of Camborne station, looking east towards Paddington around 1912.

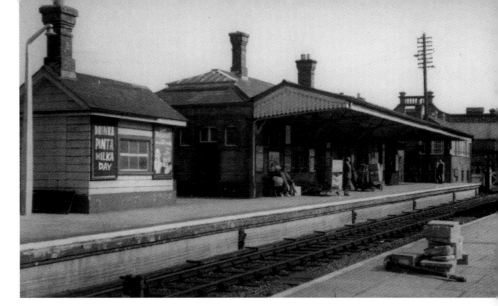

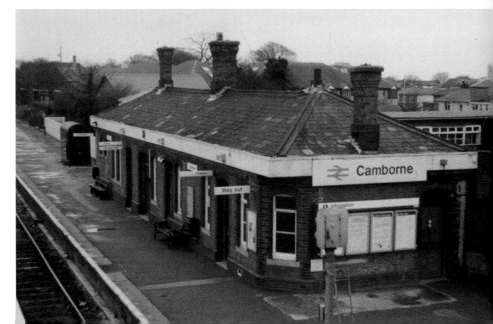

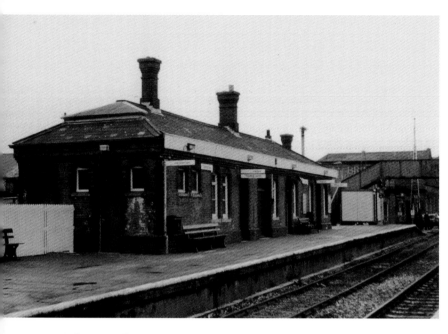

Right: Camborne – The Station Building

The building is constructed of a curious mixture of English and Flemish bonding – particularly in the centre part of the platform frontage, which exhibits an untidy pattern of headers (bricks laid crossways) and stretchers (bricks laid longitudinally). The main building material is red brick, but dark purple-blue bricks are employed for decorative effect at the corners and around the doors and windows. This 1996 view shows the rear elevation of the station building, which features a projecting extension that was clearly a later addition to the Victorian fabric.

Left: Camborne – The Station Building

The main station building is on the up side, in which position it is conveniently sited for the town centre. The building is a hip-roofed structure with tall, decorative chimneys. In its original guise, it featured a projecting platform canopy, but this has now been taken down, as shown in this photograph taken on 11 March 1996. The usual booking office, waiting rooms and public toilets are provided, the building itself being a typical late Victorian GWR design. Prior to rationalisation, the up side building had been flanked by two other structures, one of these being a small 'Brunelian'-style wooden hut, while the other was a standard GWR gable-roofed signal cabin. The hut was constructed of horizontal timbers and, from its general appearance, it may have dated back to the West Cornwall period; the signal box, in contrast, was a late-Victorian structure of brick and timber construction, dating from the mid-1890s.

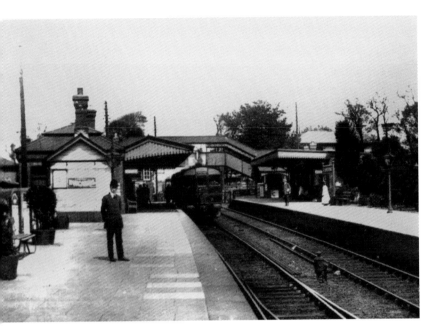

Left: Camborne

A general view of the station, looking east towards Paddington around 1912. Camborne has always handled a considerable amount of passenger traffic. In 1913, for example, the station issued 150,288 tickets, while, in the early 1930s, there were around 113,000 bookings per year, in addition to about 400-500 season ticket sales – the latter, of course being used by regular travellers. Goods traffic decreased from 76,348 tons in 1913 to an average of 19,000 tons during the 1930s. In 1932, for example, 18,326 tons of freight was handled, whereas in 1937 the corresponding figure was 21,094 tons. As in the case of Redruth, most of this goods tonnage was accounted for by general merchandise traffic, the local mining industry having gone into a steep decline by that time. On the other hand, Camborne's long association with hard rock mining has not entirely ceased, and the town is still the home of the world-famous Camborne School of Mines.

Right: Camborne

This final view of Camborne station is looking east towards Paddington on 11 March 1996. Facilities on the down platform are now confined to a simple 'bus stop' waiting shelter, though in steam days a substantial waiting room had been provided on the down side. The up and down platforms are linked by a plate girder footbridge, which is dated 1940, and replaces the fully roofed bridge that can be seen in some of the accompanying photographs.

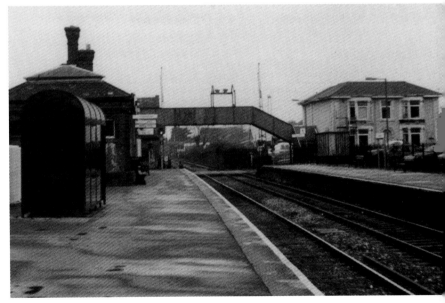

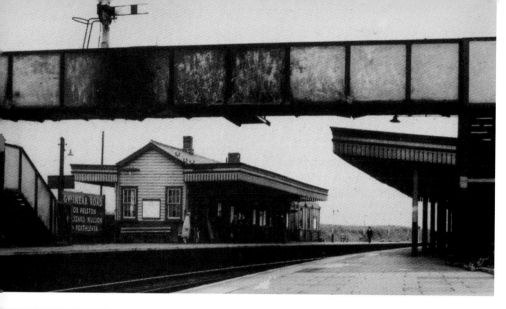

Gwinear Road

Departing from Camborne, down trains continue south-west towards Gwinear Road on falling gradients of 1 in 70 and 1 in 60. At Penponds, roughly midway between Camborne and Gwinear Road, the line crosses the 121-yard Penponds Viaduct (313 miles, 36 chains), which was one of the longest on the West Cornwall route prior to its reconstruction at the end of the nineteenth century.

The evolution of Gwinear Road station (314 miles, 64 chains) was a long and somewhat complex process that started as far back as 1843, when regular passenger services commenced running on the Hayle Railway. Contemporary press reports make no mention of a station at Gwinear Road, though trains may have called to pick up or set down passengers on an informal basis. Gwinear Road appeared in the timetables for the first time in 1852, suggesting that the first 'proper' station had been brought into use under West Cornwall Railway auspices. In those early days, the station consisted of a single platform on the down side of the line, with a run-round loop and sidings for goods traffic.

The station was reconstructed during the 1880s, when the Helston Railway was linked to the main line via 'a siding near the Gwinear Road station'. The Helston line was opened on 9 May 1887, and in its rebuilt form Gwinear Road became a three platform station, with two main line platforms and an additional platform for branch line traffic on the down side. The main station building, on the down side, was a timber-framed structure with a low-pitched gable roof and projecting canopies, while a smaller waiting room was provided on the up platform. The up and down platforms were linked by a plate girder footbridge, which was authorised in May 1907 at an estimated cost of £350, although the final cost (May 1909) was £354 16s 10d. The upper photograph shows the down side building and the lower view shows the building on the up side; both photographs were taken during the 1960s.

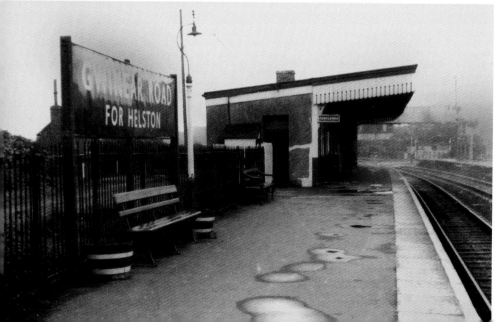

Gwinear Road

Right: A general view of Gwinear Road station looking east towards Paddington during the early years of the twentieth century. The level crossing that can be seen beyond the platforms crossed the running lines at an awkward angle and, on a minor point of detail, it is interesting to find that the gates needed to protect this skew crossing were said to have been the longest in Cornwall.

Below left: Looking westwards from the footbridge during the early 1900s.

Below right: An unidentified '45XX' class 2-6-2T runs around its train in the Helston branch platform on 2 September 1936. The Helston branch was closed on Saturday 3 November 1962, and Gwinear Road was itself closed to passengers in October 1964. Goods facilities remained in use for a few more months, but all remaining sidings were taken out of use in August 1965, and little now remains of this once-busy junction station.

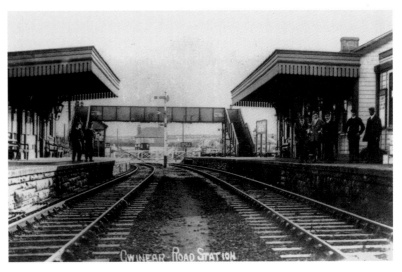

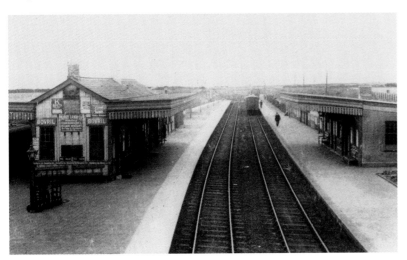

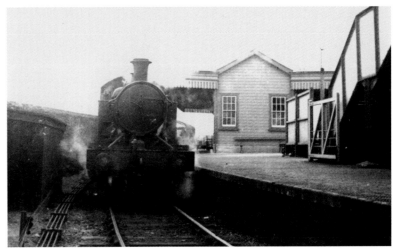

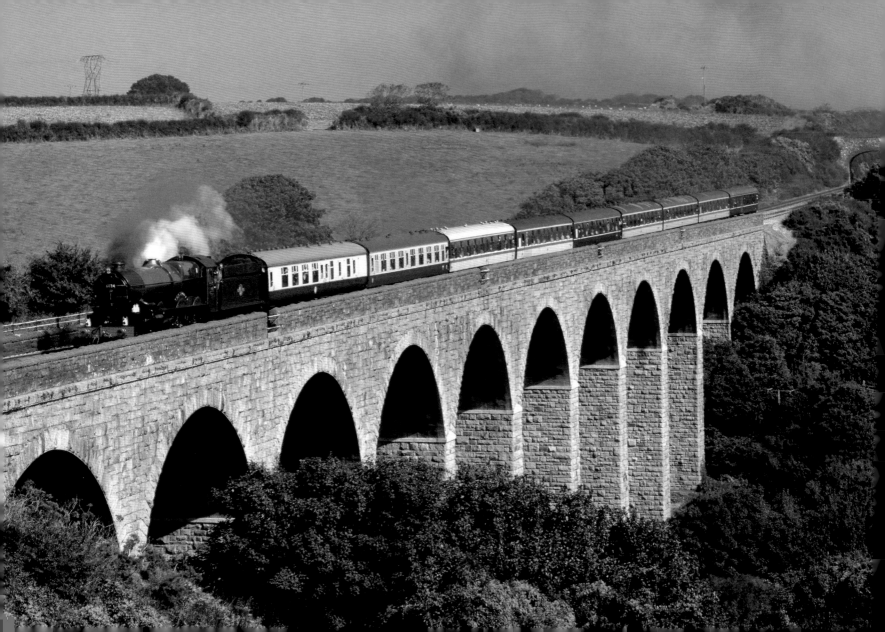

Hayle

From Gwinear Road, the route continues its descent, the steepest gradient on this section being at 1 in 59. Angarrack Viaduct (316 miles, 39 chains), about 1¾ miles beyond Gwinear Road, is an impressive structure some 240 yards in length that towers 100 feet above local ground level. In the very early days, a small station was provided at Angarrack, but this obscure stopping place was closed around 1852/53. Continuing south-westwards, the railway falls towards Guildford Viaduct (317 miles, 12 chains), which, like its neighbour at Angarrack, was formerly constructed of timber. Guildford Viaduct is 123 yards long and 56 feet high.

Opened by the Hayle Railway in 1837, Hayle station (318 miles, 18 chains), was a two platform stopping place, with a goods loop on the up (north) side, and a single dead-end siding on the down side. The main station building was on the down platform, and there was an additional waiting room on the up side. The two 440-ft platforms were linked by a girder footbridge, and there was a typical 'Brunel'-style goods shed on the down side. Other facilities included an engine shed, a water tower and a standard Great Western signal cabin – the latter structure being distinguished by its cantilevered upper storey. The busy goods branch to Hayle wharves left the main line at the western end of the goods loop and, like other industrial sidings en route to Penzance, this short branch originated back in the days of the Hayle Railway.

Hayle station dealt with approximately 52,000 tickets per annum during the first three decades of the twentieth century. In 1938, for example, 55,006 ordinary tickets were issued, plus 367 seasons, while goods traffic amounted to around 22,000 tons of freight a year during the 1930s. The upper picture, from a postcard of *c.* 1912, looks east towards Paddington, and the simple, timber-framed station building visible beyond the plate girder footbridge. The lower view is looking west towards Penzance, probably around 1920.

Opposite: Hayle

'King' class 4-6-0 No. 6024 *King Edward I* crosses Angarrack Viaduct at the head of the 5.30 p.m. Pathfinder Tours Paddington to Penzance, 'Penzance Pirate' rail tour, on 19 September 1998. Although not immediately apparent from this view, the village of Angarrack is situated directly underneath the viaduct, and some of the houses are only a few yards away from the base of the piers.

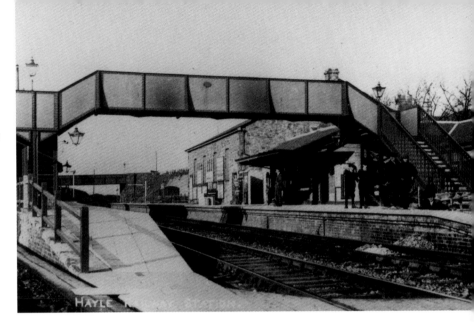

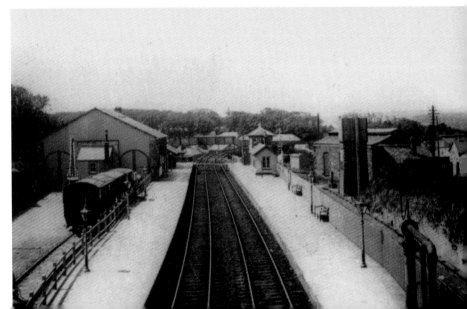

Left: Hayle – Station Infrastructure

Unlike many of the other stations between Truro and Penzance, Hayle retained its West Cornwall buildings throughout the Great Western period, and for this reason it presents an interesting comparison with the rebuilt stations found elsewhere on the former West Cornwall route. The up and down station buildings were both simple, timber-framed structures, clad in horizontal boarding, with low-pitched gable roofs. The main down side building is fitted with a small canopy. In British Railways days, the original buildings were replaced but, early in 2014, it was announced that Hayle station would receive a major facelift worth £811,000 as part of a joint venture involving Network Rail, First Great Western, Sustrans and the local authorities. The photograph provides a detailed view of the road overbridge at the east end of Hayle station on 21 September 1996.

Right: Hayle – Rationalisation of Facilities

Class '158' unit No. 158882 in the up platform at Hayle on 21 September 1996. The station suffered a period of rationalisation during the 1960s, and most of its sidings and connections were removed in 1964 and 1967, although the Hayle Wharves branch remained in situ until 1983, with fuel, oil and chemicals being the last forms of traffic handled on this relatively little-known industrial branch. A privately owned camping coach, with accommodation for up to nine people, has been installed in a garden at the rear of the down platform, and this BR Mk.1 vehicle, known as 'Harvey', is available for holiday lets.

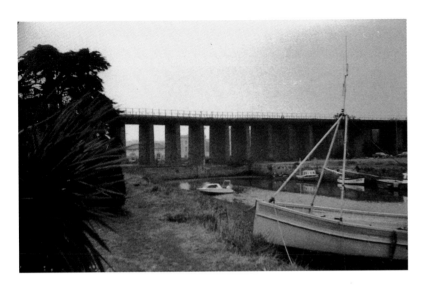

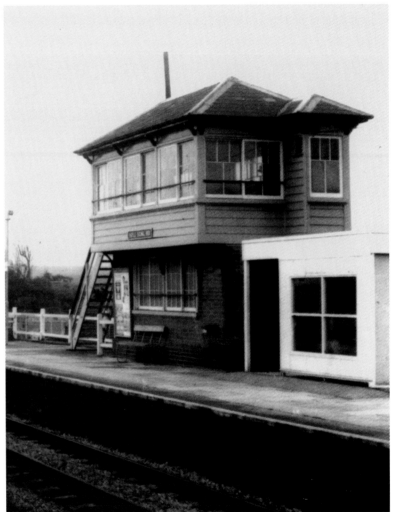

Hayle – The Viaduct & Signal Box

Above: Hayle Viaduct (318 miles, 26 chains), to the west of the station, carries the West Cornwall line above Foundry Square and the former Hayle Railway terminus. The viaduct is a girder structure with a total length of 277 yards; it is 34 feet high, and was built in 1886 in place of the earlier wooden viaduct.

Right: When resignalled by the GWR during the mid-1890s, Hayle had boasted two signal boxes, known as Hayle East and Hayle West, but these two cabins were destined to have relatively short lives, and they were replaced in the early years of the twentieth century by an entirely new box on the up platform. The new box was, in most respects, a typical GWR hip-roofed cabin, but, as a result of the relatively narrow width of the platform, it was given an unusually narrow brick locking room and the glass and timber upper floor was jetted out over the platform on supporting brackets.

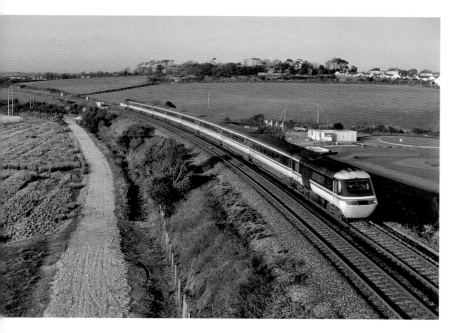

Right: Hayle

Class '50' locomotives Nos 50050 *Fearless* and 50007 *Sir Edward Elgar* are caught by the last rays of the setting sun, as they cross the River Hayle between Hayle and St Erth, with the 5.35 p.m. Pathfinder Tours Penzance to Paddington '50 Terminator' rail tour, on 26 March 1994. This was the final Class '50' worked train on the British Rail system.

Left: Hayle

An HST set headed by power car No. 43018 nears the end of its journey as it passes the 'Coast 2 Coast' go-karting track at Hayle while hauling the 12.35 p.m. Paddington to Penzance InterCity service on 26 March 1994. By the early 1990s, all long-distance passenger services on the Penzance route were being worked by HST units, with class '43' power cars at each end. InterCity Great Western services to and from Paddington were formed of eight-car sets, while InterCity CrossCountry workings between Penzance, Bristol and the north were typically formed of seven-car sets. Great Western services are still worked by eight-car HST sets, although most CrossCountry workings are now formed of 'Voyager' units.

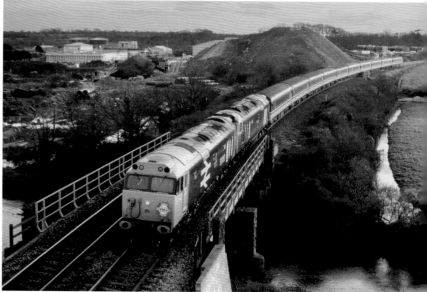

St Erth

Having crossed Hayle Viaduct, westbound trains pass through a shallow cutting and then emerge onto a low embankment. To the right, the Hayle Estuary can be clearly seen, with the St Ives branch discernible on the far shore. Reaching a brief section of 1 in 70 rising gradient, the railway curves leftward to enter St Erth station (319 miles, 65 chains), and with the St Ives line converging from the right, trains come to a stop in the gently curving platforms at this attractive country junction.

Opened on 11 March 1852, the station was originally known as St Ives Road, but its name was changed following the opening of the St Ives branch on 1 June 1877. Three platforms are available, and the main up and down platforms are around 500 feet long, while the St Ives branch bay has a length of around 300 feet. The branch bay formerly had its own run-round loop, and there were, in addition, four dead-end goods sidings on the up side of the line, together with two further sidings in the 'V' of the junction and two long refuge sidings on the down side. The main station building is on the up side, and the up and down platforms are linked by a standard Great Western covered footbridge.

The colour view shows the platforms and footbridge in January 2002, looking east towards Paddington, while the black-and-white photograph is looking westwards along the branch platform around 1920.

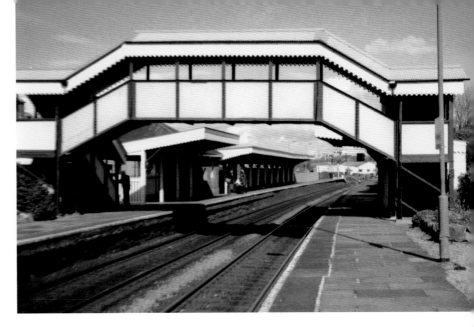

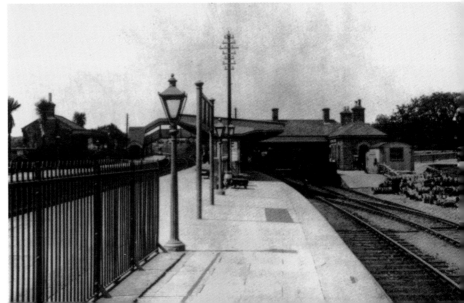

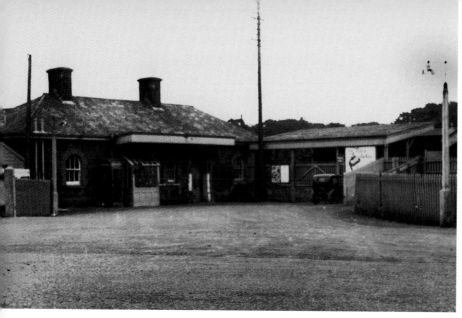

St Erth – The Station Buildings

Architecturally, St Erth is quite unlike the neighbouring stations at Redruth and Camborne. The main buildings, on the up side, are solidly built of local granite, with arched window and door apertures. Prior to rationalisation, the main station building had contained a full range of facilities for the travelling public, including a booking office, general waiting room, ladies' waiting room, parcel office, stationmaster's office and public toilets for male and female passengers. A projecting wing of the 'L'-shaped main building also contained a refreshment room, which was popular with local farmers and traders who gathered there when bringing items to the station for despatch by train.

The up platform is covered, for much of its length, by wooden canopies with decorative valancing and, as the adjacent branch platform is at a lower level than the main line, the main canopy is angled in such a way that it can provide protection for both levels. Facilities on the down platform consist of a small, gable-roofed waiting room built of dressed granite, which sports a small canopy. There is also a small, timber-built waiting shelter, and the station is signalled from a brick and timber signal cabin on the up side of the running lines. The signal cabin is a typical gable-roofed box dating from the mid-1890s, with small paned windows and other architectural features common to Great Western signal boxes built at that time. Internally it contains a 69-lever frame.

Opposite: St Erth

A view of the branch platform around 1960. A '45XX' class 2-6-2T is standing on the short siding at the end of the run-round loop which, for some obscure reason, was known to local railwaymen as 'Uncle John'!

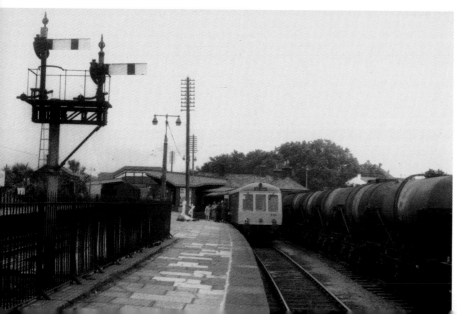

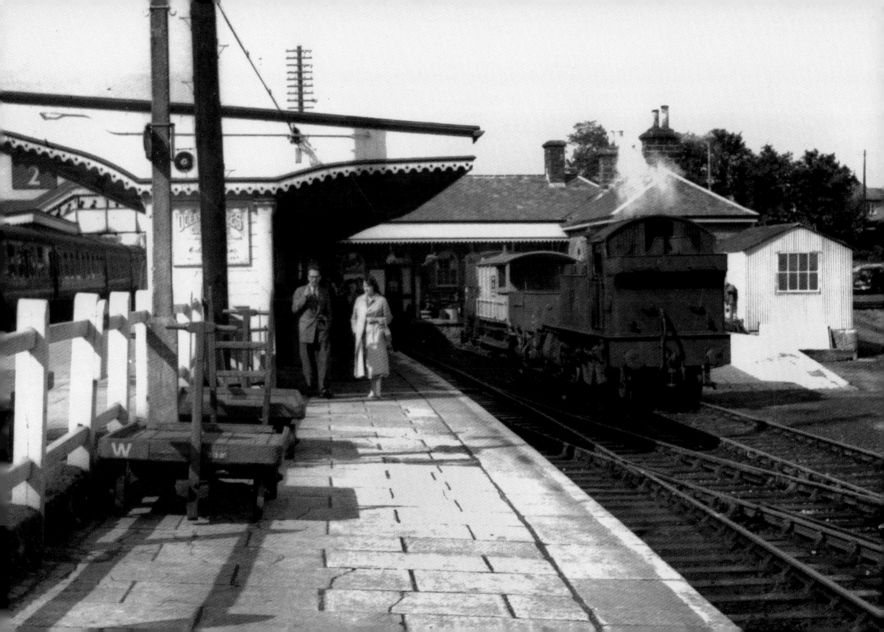

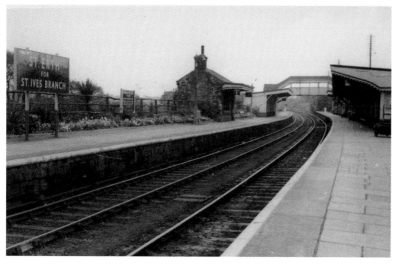

St Erth

Left: A general view of the station during the early 1960s, looking west towards Penzance with the down side station buildings visible to the left.

Below left & below right: There are two canopies on the up platform, the main canopy being parallel to the bay platform, while a much shorter wooden canopy is provided between the station building and the footbridge, as shown in these two photographs taken in 2002.

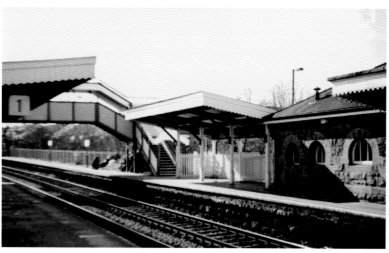

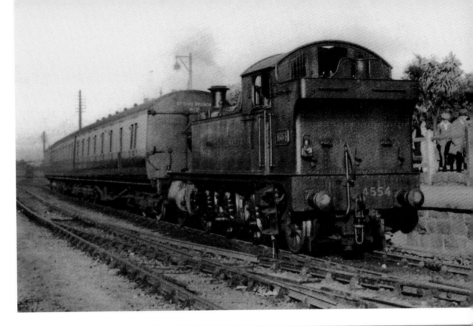

St Erth

Above: The St Ives branch train waits in the bay platform on 3 September 1936, the locomotive the '45XX' class 2-6-2T No. 4554.

Below: Looking eastwards from the footbridge in 2002. The standard GWR signal box is discernible in the distance.

St Erth handled around 30,000 passenger bookings a year in the years before the First World War, and this level of traffic remained constant during the 1920s and 1930s. In 1932, for example, 28,851 tickets were issued, while season ticket sales totalled 158. On the freight side, the station was one of the less busy stations on the West Cornwall line. In 1903 it handled only 5,208 tons of freight, though by 1930 this modest figure had increased to 9,934 tons. Later, however, a private siding agreement was signed with Unigate and, by the 1930s, the station was sending large amounts of milk to London for consumption in the capital; the 1938 Railway Clearing House *Handbook of Stations* shows that the creamery was then operated by United Dairies.

In recent years, St Erth station has generated around 200,000 passenger journeys per annum. In 2011/12, for example, it was used by 202,362 passengers, rising to 206,166 in 2012/13.

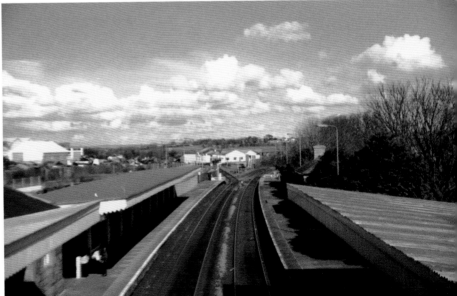

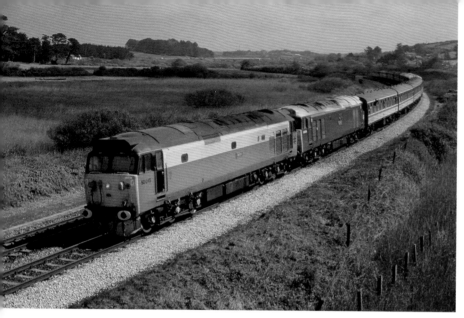

Marazion

From St Erth, the West Cornwall line sweeps south-westwards towards the south coast of Cornwall, and Marazion station (323 miles, 42 chains) is situated virtually on the sea shore. This station was opened on 11 May 1852 and closed with effect from 5 October 1964. As trains approach the former station, travellers are rewarded with a breathtaking view of St Michael's Mount – a fairytale castle rising majestically from an enchanted Celtic sea. For holidaymakers (many of whom have journeyed from distant London or the Midlands), the sudden and dramatic appearance of the Mount heralds the end of the long journey westwards, and the start of summer holidays in and around Mount's Bay, or in the remote villages of West Penwith or the Lizard Penisula.

Above: Class '50' locomotives Nos 50015 *Valiant* and 50008 *Thunderer* glide round the curve at Marazion, with the Pathfinder Tours 'Cornish Centurion 2' railtour on 4 May 1991. These two engines had been repainted in 'Dutch' and 'Laira blue' liveries respectively, for the 'Cornish Centurion' tour earlier in the year. At the same time, they were transferred to the Network South East Waterloo to Exeter reserve pool, although in reality they did very little work apart from hauling railtours.

Below: In common with St Erth and other stations in the far west of Cornwall, Marazion handled large amounts of broccoli and other perishable traffic, most of which was despatched to the London markets. Broccoli traffic remained heavy for many years. In 1936, for instance, *The Great Western Railway Magazine* reported that no less than 30,000 tons had recently been sent from Marazion, Helston, Penzance and other stations in west Cornwall. The photograph shows an unidentified 'Hall' class 4-6-0 at the head of a broccoli special from West Cornwall to London.

Marazion – The Station Buildings & Other Infrastructure

Marazion was known, for many years, as 'Marazion Road', the name being shortened to Marazion on 1 October 1896. When opened in 1852, Marazion had been a very small stopping place, with a typical Brunel designed timber station building. However, the station was reconstructed during the 1880s, the earlier West Cornwall infrastructure being replaced in its entirety by solid granite buildings that were specially designed to enhance the 'Cornish Riviera' atmosphere. The main station building was situated on the down side, and there was a much smaller waiting room on the opposite platform – both of these buildings being constructed of dressed granite blocks. The roofed, plate girder footbridge resembled that at St Erth, and there was a standard Great Western signal cabin to the west of the station building on the down platform. The latter structure was a gable-roofed brick and timber structure with ornate finials and a tall brick chimney.

Until the late 1920s, the road from Marazion to Penzance had been carried across the line by means of a level crossing at the eastern end of the platforms, but, when the line was doubled between Hayle and Marazion in June 1929, the opportunity was taken to replace the crossing with the skew girder bridge, which remains in use to this day. The upper picture is looking east towards Paddington during the 1930s, whereas the lower photograph was taken in the 1960s, after removal of the platforms.

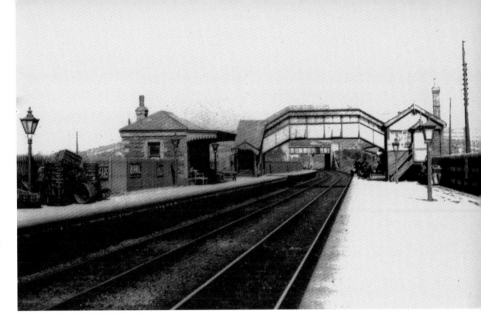

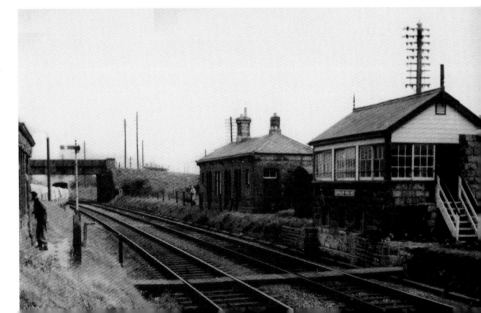

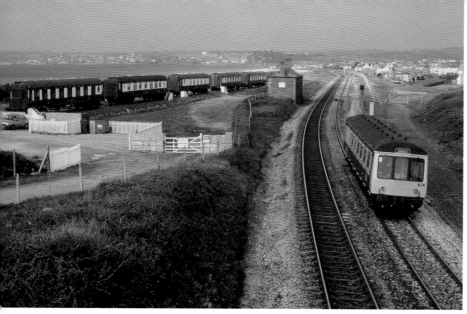

Marazion – The Pullman Camping Coaches

Marazion was associated with camping coaches for many years. Such coaches were first introduced by the London & North Eastern Railway during the mid-1930s, but the Great Western was quick to follow suit and, in 1934, *The Railway Magazine* announced that redundant GWR passenger vehicles were being adapted for use as 'railway caravans for the holiday camper'. The Marazion camping coaches survived long after the closure of the station. There were, at the end, no less than six camping coaches at this location, all of these being former SR Pullman cars used by the British Railways Staff Association. The vehicles in question were Nos W9869 *Mimosa*, W9870 *Calais*, W9871 *Flora*, W9872 *Juno*, W9875 *Aurora* and W9874 *Alicante*. They all dated from the Pre-Grouping period, the oldest having been built in 1912.

The Marazion Pullmans remained in use throughout the 1960s and '70s, though in later years the practice of sending them to Swindon every autumn and returning them in the following spring was abandoned, and the veteran coaches were, as a result, exposed to the elements for twelve months every year. The siding upon which they were stationed was disconnected from the running lines, and grass began to grow between the rails and sleepers. In 1985, the six Pullman cars were sold to a hotel owner who hoped to maintain them as holiday accommodation. There was some attempt to refurbish the vehicles, but, in 1997, they were broken into by vandals. Valuable marquetery panels were stolen by the intruders, and following this setback the owner offered the cars for sale. *Flora*, *Mimosa* and *Alicante* were eventually moved to a new home at Petworth, in Sussex, but the three remaining vehicles were scrapped on site.

The upper view shows class '112' single unit railcar No. 55012 passing Marazion, while working the 10.06 a.m. Penzance to St Ives service on 4 May 1991. This panoramic view shows Penzance in the background, together with the famous Pullman coaches, marooned on their own short section of track (No. W9871 *Flora* is nearest to the camera). The lower picture shows class '47' locomotive No. 47242 passing Marazion with a down van train on 25 July 1978.

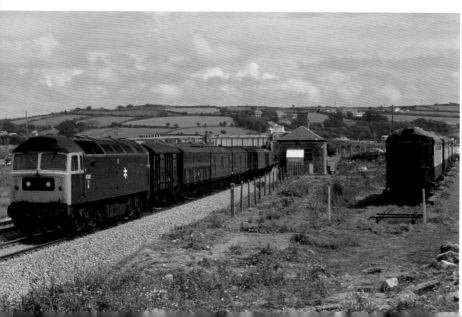

Penzance – Evolution of the Station

With the journey's end now virtually in sight, down trains proceed along the shore line towards their destination, passing, on the right, the site of the former steam locomotive depot at Long Rock (324 miles, 0 chains), which was adapted for use as a diesel depot in the late 1950s. From Long Rock, the line continues westwards, with the sea on the left-hand side and extensive empty stock sidings visible to the right. Running along a long embankment that replaced the wooden Penzance Viaduct in 1921, trains soon reach Penzance station. Here, the Great Western Railway main line ends with some formality, in an attractive four-platform terminus, which is 325 miles, 37 chains from Paddington via the old main line (or 305 miles, 18 chains via the 'Berks & Hants' route).

When opened on 11 March 1852, the original station had been little more than a branch line terminus, with cramped platform facilities and a minimal track layout. The original West Cornwall terminus was clearly inadequate in relation to increasing traffic requirements and, in 1879/80, the station was extensively rebuilt with much improved accommodation for both passenger and freight traffic. Further changes took place after the abolition of the broad gauge in 1892, while in 1937 the Great Western again remodelled the platforms and track layout in order to provide sufficient accommodation for holiday traffic.

In its present-day form, the terminus has four long terminal platforms, the westernmost extremity of the station being covered by the 1879/80 overall roof, while the main terminal buildings are situated at right angles to the buffer stops. The accompanying photographs, both taken during the early 1900s, show the station from the adjacent Chyandour Cliff Road, which is on a higher level than the railway and provides a grandstand view of the platforms.

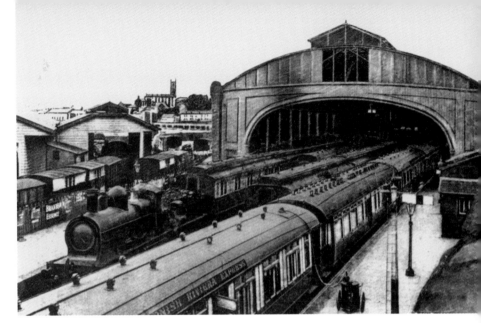

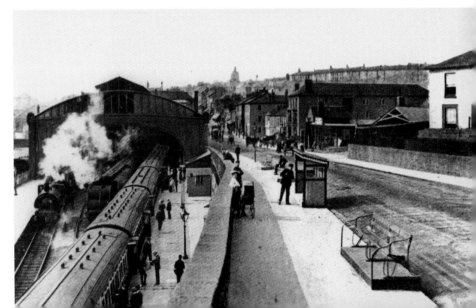

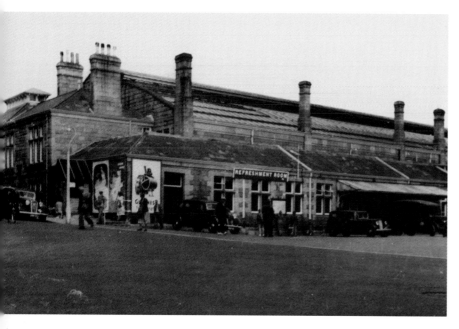

Left: **Penzance – The Main Station Buildings**
This exterior view of Penzance station, photographed around 1950, shows the granite station buildings that were erected as part of the 1879/80 reconstruction scheme. These buildings, which are solidly constructed of regularly coursed stonework, are situated at a higher level than the platforms. The station building is a split-level design, with its waiting rooms at platform level and the original booking office at street level. Access from the old booking hall to the platforms was via a stairway and a raised balcony – the latter feature providing an ideal vantage point from which to view the constant activity on the platforms below. The platforms are numbered in sequence from 1–4, platforms 1, 2 and 3 being protected at their westernmost ends by the overall roof, while platform 4 terminates in the open, on the south side of the train shed.

Right: **Penzance – The Main Station Buildings**
This Edwardian postcard provides a useful interior view of the station during the early years of the twentieth century. Steam railmotor car No. 45 rests against the buffer stops at the end of platform 1, while the stairway that gave access to the high level booking office can be seen to the right. The offices to the left of the booking office were used by the district inspector. Car No. 45 was built at Swindon in 1905 as one of a batch of twelve 79-ft vehicles, numbered in sequence from 41 to 52 (Lot 1279).

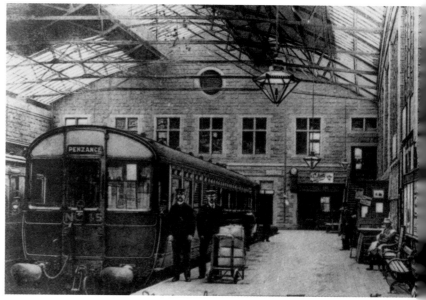

Penzance – The Old Goods Yard

In West Cornwall days, the station's goods facilities had been concentrated on a cramped site between the passenger station and Albert Quay. The original goods yard contained a typical Brunelian timber goods shed with two covered sidings, one of which extended beyond the shed to serve Albert Quay. The original engine shed had been sited beside the goods shed, and this structure was later adapted for use as a goods loading facility. The two sheds then formed an enlarged goods shed containing three covered sidings, while two additional goods sidings terminated in end-loading docks, the longest of which had a length of 270 feet. The main goods shed contained a central loading platform with a length of 140 feet. Additional loading facilities were subsequently installed a little way along the line at Ponsandane, and this new site was much enlarged and expanded during the 1930s, when the Great Western decided to develop Ponsandane sidings as the town's principal goods yard.

The original WCR goods yard was radically altered during the 1930s alterations and, thereafter, the site of the old yard became a loading area for parcels and perishables. The latter form of traffic was of particular importance at Penzance, and large quantities of broccoli, potatoes and fish were handled every year, together with consignments of flowers from the Isles of Scilly. At the end of the Victorian period, the demand for flowers was almost insatiable, and by 1910 no less than 450 tons of flowers were being sent to London each year. In the 1930s, the station handled well over 300,000 consignments of fish, flowers, vegetables and parcels each year.

The upper photograph shows the station and original goods yard prior to the 1937 reconstruction scheme, while the lower view shows an unidentified 0-6-0 pannier tank during a shunting manoeuvre. The old goods shed being can be seen to the left in both pictures.

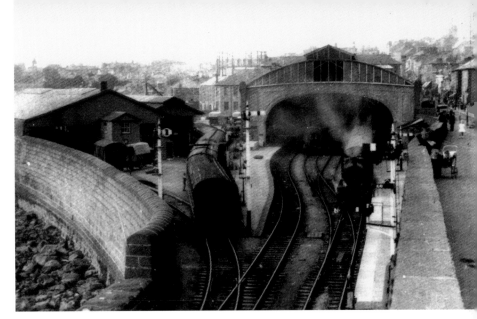

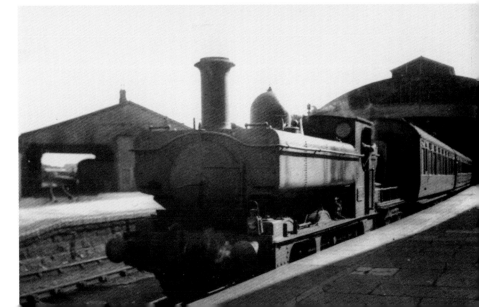

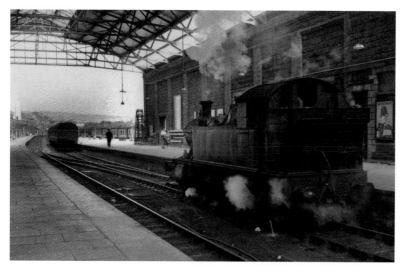

Penzance – Interior Views

Left: A glimpse beneath the cavernous train shed at Penzance. 'Small Prairie' tank No. 4566 is running round its train in platform 3.

Below left: Another view showing the interior of the train shed during the British Railways period. Spare coaches occupy the dead-end spur at the end of platform 2. The internal arrangements have been altered in recent years, and the booking office is now situated at platform level in the south-western corner of the station buildings.

Below right: A view of the platforms from the booking office balcony during the British Railways period around 1958. The parcels office and gentlemen's toilets can be seen to the right of the picture, while Wymans kiosk occupies a prominent position on the station concourse.

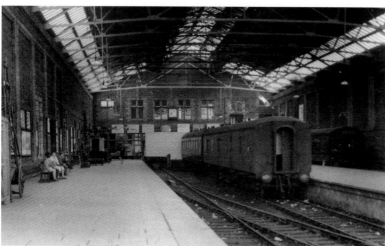

Penzance – Steam & Diesel

Right: A busy scene at Penzance station during the 1950s. An unidentified '45xx' class 2-6-2T carries out shunting operations in platform 2, while 'Modified Hall' class 4-6-0 No. 6965 *Thirlestaine Hall* stands in platform 3 with an up passenger train.

Below left: Class '47' locomotive No. 47484 *Isambard Kingdom Brunel* stands alongside platform 2 with the 10.20 a.m. stopping service from Plymouth on 20 May 1981. The formation consists of four BR Mark 1 coaches, comprising a brake second, second, composite and a full brake vehicle.

Below right: This *c.* 1981 view shows a newly arrived HST set in platform 1, and a local train to Plymouth in platform 3.

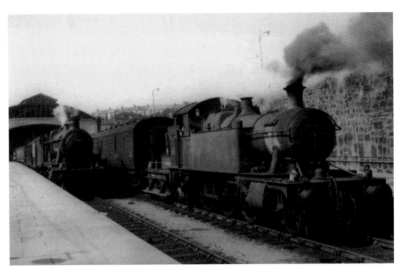

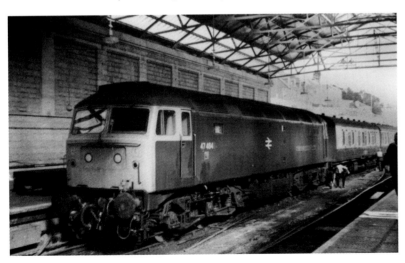

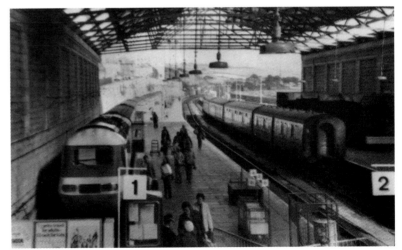

Penzance – Platform Views

Left: This platform-end view, taken in October 1996, is looking east towards Paddington. An HST set is about to depart from platform 1.

Below left: A four-car formation, consisting of class '142' units Nos 142021 and 142022, waits in platform 1. The four-wheel class '142' units were introduced in 1985, and thirteen were sent to Cornwall for work on the local branch lines; they were known as 'Skippers', and adorned in Great Western style chocolate and cream livery. It soon became clear that these rigid wheelbase vehicles were totally unsuited for work on steeply-graded Cornish branch lines such as the Looe branch – the problems of excessive flange wear and loud screeching noises on sharp curves being so severe that the 'Skippers' were transferred en masse to the north of England in 1987.

Below right: 'Skipper' unit No. 14022 lurks beneath the train shed, probably in the summer of 1986.

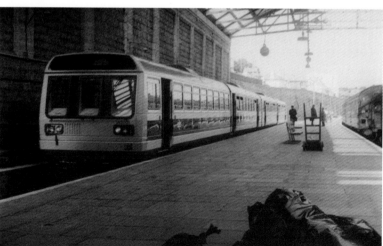

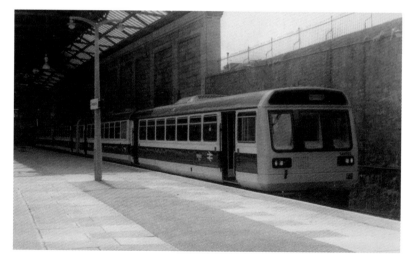

Right: Penzance – The Signal Box

The terminus is signalled from a typical Great Western brick and timber signal box. This characteristic hip-roofed structure is sited on the up side, a little way beyond the end of platform 1. The single-storey building that can be seen to the left of the box was the examiners' cabin. Other signal boxes were sited at Ponsandane (54 chains to the east of the station), and at Long Rock (1 mile, 54 chains from Penzance). Ponsandane Box was notable in that it sported a flat roof, which was supposed to have been provided to please local landowners, who would otherwise have been denied an unobstructed view of St Michael's Mount.

Left: Penzance – The Old Coke Store

This somewhat mysterious blocked archway in the retaining wall at the rear of platform 1, appears, at first glance, to be the entrance to a tunnel under Chyandour Cliff Road. It was apparently constructed around 1852/53 as a coal and coke store, although later plans reveal that this underground chamber was used as a 'fitting shop and store', presumably in connection with the locomotive department. The store was provided with a narrow platform to facilitate loading and unloading.

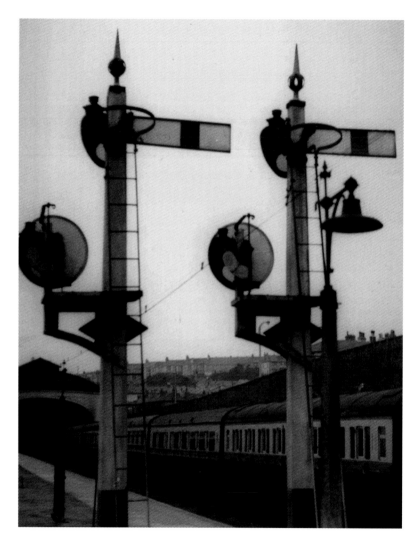

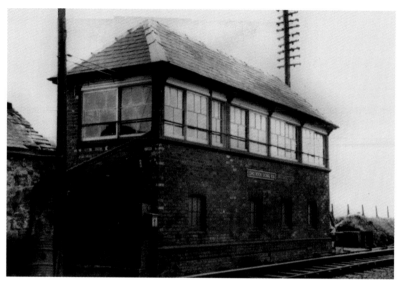

Penzance – Signalling Details

Above: A detailed study of Long Rock Signal Box, which stood on the down side of the running lines within yards of the sea, and controlled access to and from the adjacent Long Rock motive power depot. Although in most respects a standard GWR structure, the cabin featured a hipped roof with an unusually steep pitch. The box was brought into use in 1912, and its frame was renewed in 1958. This box was finally closed in June 1974.

Left: A detailed view of the wooden-posted starting signals at the end of platforms 3 and 4. The shunting discs mounted on each post controlled access to nearby sidings, while the small diamond-shaped boards attached to the signal posts indicate that Nos 3 and 4 platform lines were track circuited.

Penzance – Some General Details

Right: This view is looking westwards along platform 4 in 2002. The former parcels and perishables bays to the left of the picture occupied the site of the original goods depot. They were later adapted for 'motorail' traffic.

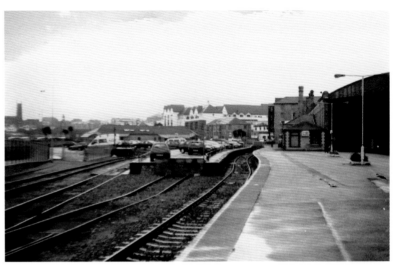

Below left: A further view of the former parcels and sundries bays.

Below right: Platform 4 in October 1996.

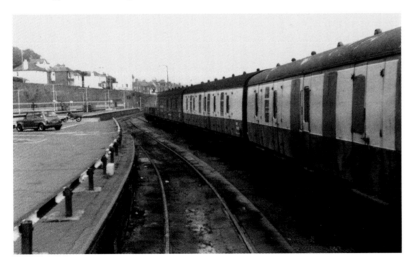

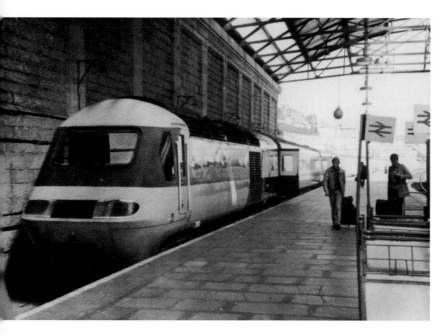

Left: **Penzance**
An HST set stands in platform 1 on 20 May 1981.

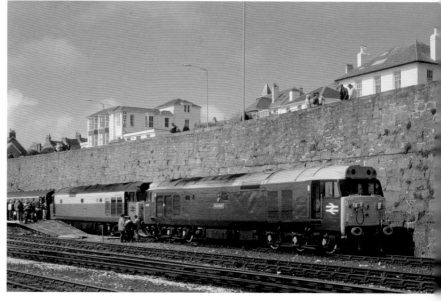

Right: **Penzance**
Class '50' locomotives Nos *Thunderer* and 50015 *Valiant* draw admiring glances from rail tour passengers on the platform and passers-by on the road above, as they wait in platform 1 at Penzance on 4 May 1991, prior to working the Pathfinder Tours 'Cornish Centurion 2' rail tour to Manchester Piccadilly.

Penzance – Road Motor Services

The GWR was a pioneer in the use of motorised road feeder services, the company's first 'road motor' route between Helston and the Lizard having been one of the very first rural bus services in the country. By 1910, the Great Western had introduced road motor services on a very large scale, and Penzance was an important centre for the employment of such vehicles, with services radiating to Land's End, Porthcurno, St Just, Zennor and other destinations.

Unfortunately, the undoubted success of the Great Western bus fleet led to complaints from the road transport industry to the effect that railway companies such as the GWR did not have parliamentary consent to operate road services. The GWR therefore obtained new powers under the provisions of the Great Western (Road Transport) Act 1928, which allowed the company to own, work and use motor vehicles in its own right, and to enter into agreements with other parties for the operation of road transport services. By virtue of these powers, the GWR relinquished its own fleet of motor buses and, by 1933, all Great Western bus services had been transferred to 'railway associated' bus companies such as the Western National Omnibus Co.

The accompanying photographs were both taken at Penzance during the early 1900s. The upper view shows GWR 'road motor' No. 6 (AF65), while the lower photograph shows car No. 78 (AF161). No.6 was a Milnes Daimler 16 hp vehicle, while No. 78 was a 24-hp Straker-Squire covered charabanc. The Great Western buses carried an attractive version of the company's traditional chocolate and cream passenger livery, and they worked in conjunction with the trains as useful feeders for the railway system.

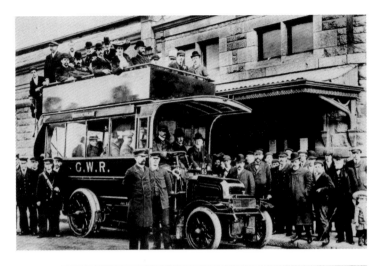

Penzance – Long Rock Shed

Above: A view of Long Rock engine shed in the 1930s. Opened in 1914, Long Rock motive power depot replaced an earlier shed that had been sited further along the line towards Penzance station. The new shed was a four-road, brick-built structure, with an additional bay on the north side for repair work. The depot was equipped with the usual facilities for coaling, watering and day-to-day maintenance operations. The shed proper measured approximately 210 feet by 66 feet at ground level, and the turntable was large enough to accommodate 'Castle' class 4-6-0s, or other Great Western main line locomotives

Below: Class '08' diesel shunter No. 08801, Penzance's resident shunter, rests between duties at the Cornish terminus on 4 May 1991. Sent new to St Blazey shed in 1960, No. D3969 (as it then was) was reallocated to several depots in northern England, before returning St Blazey in 1984. Its move to Laira a few years later resulted in it being outstationed at Penzance. The year before this photograph was taken, No. 08801 was damaged in a collision with class '47' No. 47538, while en-route from Long Rock to Penzance.

Opposite: 'Grange' class 4-6-0 locomotive No. 6868 *Beenham Grange* and 'Castle' class 4-6-0 No. 7022 *Hereford Castle* stand in the engine sidings at Long Rock on 5 August 1962. 'Castle' class 4-6-0s appeared on the Cornish main line in the period immediately before the Second World War. In BR days there was considerable variety in terms of motive power, with 'Castles' or 'Counties' putting in regular appearances on the Cornish Riviera Express, while other main line workings were handled by 'Halls', 'Counties', or 'Granges'. There seemed to be no clear pattern in the employment of 4-6-0 classes in Cornwall, and lineside observers could usually be sure of seeing a procession of 'Halls', 'Counties', 'Castles' and 'Granges' on main line passenger duties.